William James Bennett

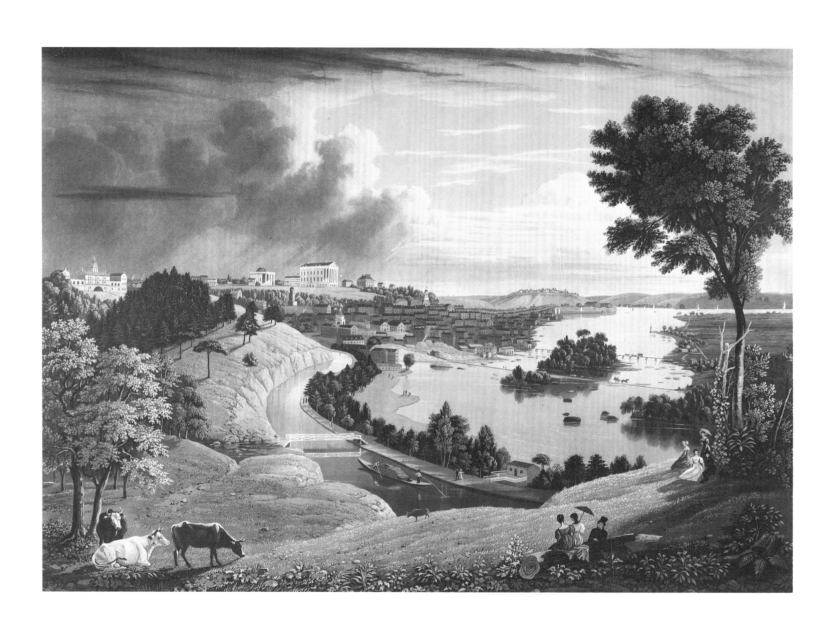

WILLIAM JAMES BENNETT

Master of the Aquatint View

GLORIA GILDA DEÁK

With an introductory essay by

DALE ROYLANCE

Checklist and commentaries by

ROBERTA WADDELL *and* THERESA SALAZAR

The New York Public Library

1988

Published for the exhibition "William James Bennett: Master of the
Aquatint View," presented at The New York Public Library,
October 29, 1988–February 18, 1989, and at The Leonard L. Milberg Gallery
for the Graphic Arts, Princeton University Library, April 9–June 18, 1989

On the cover:
New York, from Brooklyn Heights. 1837. Colored aquatint, after
John William Hill. The Phelps Stokes Collection, Print Collection
[checklist no. 34]

Frontispiece:
Richmond, From the Hill above the Waterworks. 1834. Colored aquatint,
after George Cooke. The Phelps Stokes Collection, Print Collection
[checklist no. 25]

Photography (figs. 1, 3–9, 14, 17, 22, 28–31, 35, 39):
Philip Pocock

◆　◆　◆

Library of Congress Cataloging-in-Publication Data
Deák, Gloria-Gilda, 1930–
William James Bennett : master of the aquatint view.
Bibliography: p.
1. Bennett, W. J. (William James), 1787–1844—
Exhibitions.　2. Landscape in art—Exhibitions.　3. New
York Public Library—Art collections—Exhibitions.
4. Aquatint—Private collections—New York (N.Y.)—
Exhibitions.　I. Title.
NE2012.B44A4　1988　　　769.92′4　　　88–25268
ISBN 0–87104–411–0 (pbk.)

Contents

Acknowledgments

THE NEW YORK PUBLIC LIBRARY's American historical prints are in constant demand as visual records of our nation's history. But beyond their documentary value, many of the prints are also beautiful and technically skillful works of art. Among the most remarkable are the nineteenth-century aquatint views of William James Bennett, richly represented in the Phelps Stokes Collection of American Historical Prints, housed, with other holdings of Americana, in the Print Room of The Miriam and Ira D. Wallach Division of Art, Prints and Photographs.

This exhibition and its catalogue offer the opportunity to see with fresh eyes Bennett's remarkable views of America's growing urban centers in the context of an established British topographical tradition. Our sincere gratitude is extended to Leonard L. Milberg, a loyal and generous supporter of The New York Public Library and its Print Room, who originally suggested that Bennett would be a worthy subject for study. As a serious scholar and enthusiastic collector of American historical prints, he has sponsored the publication of this catalogue and has made it possible for the exhibition to be shown at The Leonard L. Milberg Gallery for the Graphic Arts, Princeton University Library. Through Mr. Milberg's ongoing endowment to conserve works in the Stokes Collection, Bennett's glorious aquatints can be seen in a condition as close as possible to their original beauty and brilliance: thriving cities, washed in pervasive light, that suggest the spirit of optimism, pride, and confidence of a growing nation.

The exhibition at The New York Public Library has been made possible by an extraordinary gift to the Division of Art, Prints and Photographs by Miriam and Ira D. Wallach with the aim of sponsoring, among other departmental efforts, exhibitions and conservation, and by a grant from the New York State Council on the Arts.

We also wish to express our appreciation to Gloria Deák and Dale Roylance for their enlightening essays on Bennett and aquatint, to Theresa Salazar for her invaluable assistance with the checklist, the commentary, and the exhibition, and to Donald Anderle and Robert Rainwater for their support of this project. We are most grateful to Elizabeth Blackert, Fred Brauen, and John Ryan for their meticulous research assistance, and to Barbara Bergeron, Marilan Lund, and Donna Moll for their ability to transform words and pictures into a beautiful catalogue.

ROBERTA WADDELL
Curator of Prints

William James Bennett

Aquatint Engraving in England and America

DALE ROYLANCE

THE ENGRAVED VIEWS of William James Bennett (ca. 1784–1844), together with several of the most important published portfolios of early American scenery, must be seen as the American flowering of several important earlier English developments in the graphic arts. These developments include the entire idea of topography as an independent subject for prints, the emergence of the English school of watercolor drawings, and the closely related English mastery of watercolor's engraving equivalent, aquatint.

Topographical prints of city views had origins as far back as the fifteenth-century *Nuremberg Chronicle*, but truly came into their own as a popular print subject independent of cartography in eighteenth-century England. By that time awareness of the scenic world was increasingly fostered by general travel, and nearly every young gentleman was obliged to take the Grand Tour of Italy and the Continent as an essential part of his cultural education. This in turn brought new stimulus to private collecting and the related rise of the art and print market. Collecting of art, particularly prints, drawings, and color plate books, is a phenomenon closely linked with eighteenth-century English country houses and their often sumptuous libraries. There was also a newly aspiring middle class, who began to have, through colored prints and picture books, their own new window on the world. The popularity of travel pictures also led to recognition of a fundamental part of travel: the joy of returning home. The need to delineate the beauties of English towns and countryside became increasingly recognized not only by established artists, but also by a whole new breed of amateur painters. Armed with newly developed (about 1780) Reeves & Co. watercolor cakes easily portable in pocket-size painting boxes, Whatman watercolor paper, a flask of water or spirits, and possibly one of many newly published albums of *How to Paint and Draw in Water Color*, countless amateurs young and old tried their hand at art.

Two brothers, Thomas (1721–1798) and Paul Sandby (1725–1809), are recognized as the founders of the English watercolor movement, and are credited as well for the sharply rising interest in topographical landscape drawing of the English scene.

The Paul Sandby technique was simplicity itself. After stretching a sheet of Whatman watercolor paper, Sandby sketched his design in pure outline in pen and ink, then flooded large areas with flat color, usually azure for sky and a shaded amber or yellow ochre for ground. Gradations of tone were achieved, in Sandby's personal practice, with a dilution of colors with gin. Finally, when all was dry, local colors and details were added in gouache over the underpainted washes.[1] The formula of precise outline filled in with flat tonal washes in a range of tonalities from the lightest gray to nearly flat black achieved a look similar to the elegant style of many later masters of topographical watercolor painting. Francis Towne (1740–1816), Thomas Malton (1726–1801), Thomas Girtin (1775–1802), and many others created a stylistic look in watercolor attractively allied to the clean accuracy of architectural drawing, but also often expressive of the lyricism and poetry of early Romanticism.

The love of watercolor in England is also closely linked with the phenomenal development of a new tonal engraving technique, aquatint. Tone had been a problem in printmaking from the first. Shading by lines and cross-hatching only simulates tone, but printmakers had pursued the printing of multiple hatching and cross-hatching line for tonal effects to the most virtuoso extremes throughout the seventeenth century. Callot, Goltzius, and Nanteuil all used pure line to exhaustion, still to create only a visual illusion of light and shade tonality. During the same period, mezzotint was also developed as a tonal technique for

the most dramatic of chiaroscuro contrasts of tone. But far more versatile effects were to be developed in England in the eighteenth century. Stipple engraving, employed as a portrait technique by such fashionable artists as Francesco Bartolozzi (1727–1815), gave the graphic clue to the idea of halftone through the use of multiple dots, rather than lines, to create form. The next step was to find a way to create an overall texture that would print large flat tonal areas. A special effect of watercolor, the granulated wash, also suggested dots as a way of producing tone without line. (While still wet, a heavy wash of color will deposit an even array of clotted color granules when it is tilted back and forth until the water evaporates.)

A French artist and printmaker, Jean Baptiste Le Prince (1734–1781), is credited with the invention of a way to create a printing plate on which a porous tonal printing surface has been laid. In the transfer of his designs to the plate Le Prince discovered that it was possible to cover the entire surface of his copper with a fine layer of resin dust, through a porous cloth bag or in a miniature box in which a small dust storm had been created by a fan. When the copper plate is heated, the resin particles adhere to the plate. A special "stopping-out" varnish is then painted over to block out the portions of the design where gray tone is not wanted. After the back of the plate, all edges, and all areas that are to print white are carefully coated, the plate is immersed in an acid bath, where the acid etches the areas not protected by either the varnish or the resin particles. The result is an evenly textured tone of the lightest shade to be used in the print. To obtain darker tones, successive painting out of the lightest tone followed by an acid bath results in the spectrum of gray tones seen in the final print. The resulting etched plate is inked with a dauber and the surface is wiped clean to leave ink only in etched areas. Dampened paper is then placed over the plate and sent through the rollers of the intaglio press. The great pressure forces the paper into the smallest crevices of the copper plate to pick up all traces of ink. The result is astonishingly close to pen-and-ink wash drawing and was well named by Sandby "aquatinta," or tinted wash.

Paul Sandby, remembered as the father of English topographical drawing as well as of the English watercolor school, was the first artist to use the new aquatint process in England. He learned the technique from a friend, Charles Greville, who had purchased the secret from Le Prince. Sandby invented his own method of laying the resin dust ground on the copper plate, called by him "spirit ground," in which the resin particles were dissolved in gin and the mixture was poured on the plate. When the spirit evaporated, the resin particles remained in a fine, even, granulated coat, recalling both the granulated wash device of watercolor and Sandby's curious partiality to gin over water as the diluting agent in his painting.

Sandby's first book, *Twelve Views in Aquatinta from Drawings Taken on the Spot* . . . (London, 1775), is the first published use of aquatint in England. The technique, revealed at a time when watercolor was at its most popular, found an almost instant market, and flourished as the most effective printmaking process until 1840, when lithography superseded it.

Although introduced by Sandby, aquatint was to have its greatest realization in books and prints issued by the remarkable German publisher and printseller Rudolph Ackermann (1764–1834). This versatile impresario of the printing arts began his career as a London coachmaker, but changed to print- and bookseller when he established, first at no. 96 and then at no. 101 Strand, what was to become one of the most celebrated of all London bookshops (fig. 1).

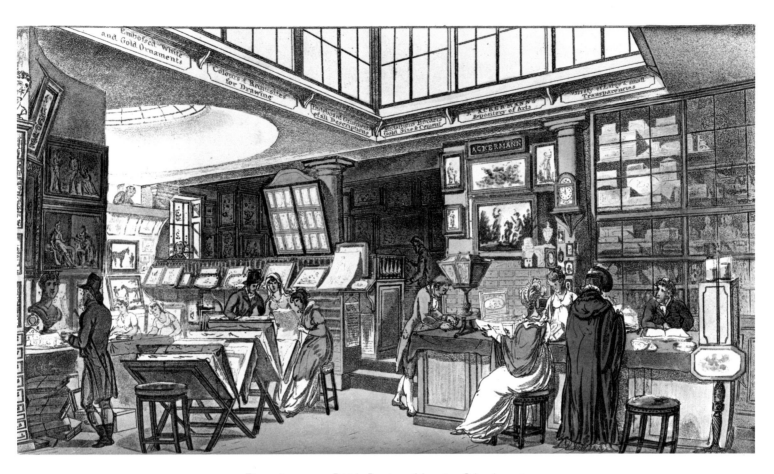

Fig. 1 Anonymous, British. *Repository of Arts*. 1809. Colored aquatint.
From *The Repository of Arts*, vol. I. Print Collection

Ackermann's "The Repository of Arts" quickly became not only the most important art library in London but also a social and cultural institution of Regency London. By 1813 Ackermann, ever active, began hosting cultural gatherings each Wednesday evening, and soon attracted the most influential figures in the world of English arts and letters. Lines written by an anonymous convert to the circle conjure the atmosphere of the place and time:

> Wits, Critics, Poets, Artists here convene,
> And all accord to animate the scene;
> Sculpture and Painting well adorn the Place,
> And classic stores the spacious tables grace . . .
> Learn GRANDEUR, learn, from one in humbler sphere,
> Who spreads so rich a mental banquet here,
> Learn Arts to foster on this social plan
> And emulate the zeal of ACKERMANN.[2]

Acting as both cultural impresario and bookseller, Ackermann soon became unofficial arbiter of Regency taste, and published in 1809 the first art periodical, to which he gave the same name as his shop, *The Repository of Arts*. This first of all art journals continued through forty volumes from 1809 to 1828, recording in extraordinary detail the life and art of the period. Pictorially enriched with hundreds of fine colored aquatints and engravings, the *Repository* even includes tipped-in swatches of printed textiles to show the latest in yard goods available for fashionable dress.

In 1808 Ackermann began an even more ambitious enterprise with the first of his incomparable series of color plate books in aquatint. Ackermann had "discovered" and befriended many of the best draughtsmen of the period. He had also established in his business at the Repository of Arts an extraordinary working crew of engravers and hand-colorers of prints. His shop was also well known as a haven for talented but impoverished aristocratic refugees from post-revolutionary France. It was Ackermann's astute idea to organize this extensive crew in projects of unprecedented ambition. The first of these was *The Microcosm of London, or London in Miniature, the Architecture of A. Pugin, the Manners and Customs by Thomas Rowlandson*. Published in twenty-six parts, the aquatint plates were the joint work of Augustus Pugin (1762–1832) and Thomas Rowlandson (1756–1827). As a collaboration of Pugin's precise architectural drawings and Rowlandson's irrepressibly lively figures, *The Microcosm of London* presents an incomparable record of the both elegant and licentious London of George IV.

The importance of Ackermann's role in this new enterprise of picture books becomes clear in a logistical glance. *The Microcosm of London* contained 104 plates, and the book was issued in 1,000 copies. Thus 104,000 separate prints were made from 104 laboriously engraved copper plates, all fully hand-colored in a uniformly beautiful style. Since children are said to have done the coloring (both Turner and Girtin worked in coloring shops as boys), the organization, supervision, and shop control must all have been formidable.

Apparently all this, as well as financing, was no problem to Ackermann since he soon embarked on other ambitious aquatint color plate books one after another. In 1812 *The History of Westminster Abbey* appeared with seventy plates, and in 1814 came *A History of The University of Oxford* and *A History of The University of Cambridge*, followed in 1816 by *The History of the Colleges*. In addition to these major color plate books Ackermann was responsible for at least seventy-one books illustrated in colored aquatint, in addition to the many series of plates in his journal, *The Repository of Arts*.

Aquatint engraving, as promoted by Ackermann and other English publishers, rose to become the supreme printmaking process in

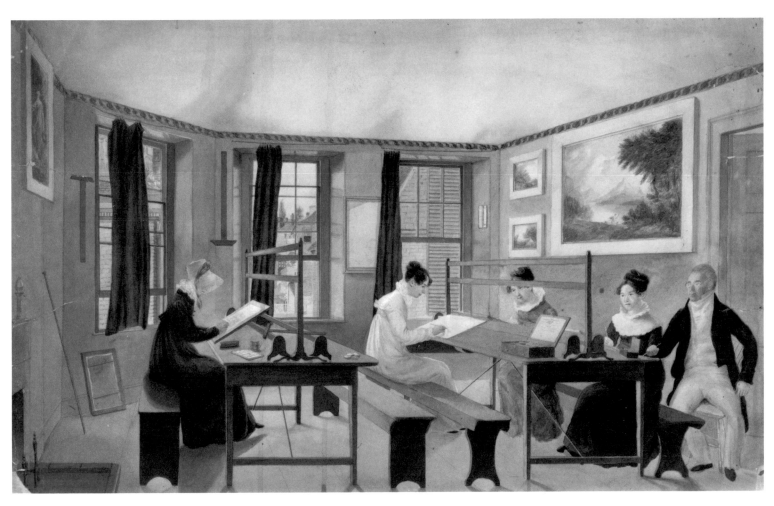

Fig. 2 Anonymous, American. *The Drawing Class*. ca. 1820. Watercolor.
Gift of Emily Crane Chadbourne, The Art Institute of Chicago

the decades between 1790 and 1830. The beauty and extent of the achievement have been obscured by the rare showing of originals to the modern public. Collectors and connoisseurs find good, complete examples only with difficulty, since the best colored aquatint books have long since been either broken up by print dealers or locked away in the rare book vaults of major institutional libraries. Exhibitions, when they occur, are inevitably highly selective of much wider possible choices, and when shown, the works are displayed under dim lighting conditions, and under glass, thus losing for the viewer most of the wonderful color and tonal sensitivity of these remarkable prints. The hand-coloring, due partly to the high degree of proficiency in watercolor of the period, but even more to the high standards of artists, publishers, and clients in Regency England, has few rivals in printmaking. The entire Regency age, full of elegance, wit, and polish, but also of poverty, low life, and ribaldry, is to be found superbly preserved, in astonishing detail, in aquatint.

Also too little realized is the significant role that English aquatint would perform in the artistic delineation of the early American landscape.

Englishmen provided many of the very earliest views of America. *The Atlantic Neptune*, published in England between 1763 and 1784, included aquatint engravings depicting the ports and coastlines of North America, and the versatile Paul Sandby, already discussed here as the "father" of English watercolor and aquatint, etched several views (including Passaic Falls in New Jersey) for the print series of *Scenographia Americana*, issued in London in 1768.

In 1792 a Scotsman, Alexander Robertson (1772–1841), came to New York City, where he started the first recorded art school in America, the Columbia School of Painting. Together with his brother Archibald, Alexander Robertson taught drawing in watercolor for reproduction in aquatint. An anonymous watercolor (fig. 2) of the period may portray just such a watercolor class as those at the Columbia School of Painting. Typical topographical drawings of the foreground, middle ground, and background formula adorn the walls.

Aquatint drawing books, giving detailed instruction on how to draw and paint in watercolor, were first published by Ackermann in London in 1796 and 1809, followed by many other printed instruction manuals. Usually carefully hand-colored, these printed albums were a great success among the countless watercolor amateurs of England, and were soon imported to America. By 1827 an American version, *Lucas' Progressive Drawing Book*, was published in Baltimore with American city views and landscapes as examples of proper watercolor subjects. John Latrobe (1803–1891), son of Washington architect and draughtsman Benjamin Latrobe, provided the designs that were engraved in aquatint by John Hill (1770–1850).

John Hill had been among the young engravers earlier employed by Ackermann for *The Microcosm of London*. He immigrated to the United States in 1816, and was soon accepted for his skills in aquatint engraving. He was also the engraver for two of the earliest and most important of early American collections of views recording the serene, still unspoiled scenery of Pennsylvania, New Jersey, and New York.

First, in Philadelphia, Hill collaborated with another English immigrant artist, Joshua Shaw (ca. 1777–1860), to produce the splendid aquatint portfolio *Picturesque Views of American Scenery*, which was published by M. Carey & Son in Philadelphia in 1819–21. Shaw writes in his preface:

In no quarter of the globe are the majesty and loveliness of nature more

strikingly conspicuous than in America. . . . Striking however and original as the features of nature undoubtedly are in the United States, they have rarely been made the subjects of pictorial delineation. . . .

John Hill then engraved in aquatint the even more celebrated *Hudson River Portfolio* after the designs of William Guy Wall (1792–ca. 1864), which appeared in published parts from 1821 to 1825, published by Henry Megarey in New York. Wall was, not surprisingly, another visiting British artist. His work was particularly admired by Thomas Jefferson.

"Engraved, Printed, and Coloured by J. Hill" is the almost ubiquitous signature line on the right-hand corner of American aquatint views between 1820 and 1830. John Hill must also be remembered as the father of the very fine early American watercolor painter John William Hill (1812–1879).

A second, in some ways even more remarkable aquatint engraver for American city views arrived in America from England by 1826. This artist-engraver, William James Bennett (ca. 1784–1844), became the quintessential English-American practitioner of the art of aquatint and, fortunately for the history of the imagery of America's young republic, found his main pictorial inspiration in its newly rising cities.

The international art scene was well set for the young Bennett's work in America. By the turn of the century, artist travelers in pursuit of the "picturesque" had made their way around the world. In America, besides the Englishmen already mentioned, there were traveling watercolorists of distinction whose work demonstrates the growing worldwide interest in foreign scenery. The Baroness Anne-Marguérite-Henriette Hyde de Neuville (ca. 1799–1849) left a remarkable pictorial diary of her American travels, and the Russian diplomat

Pavel Svinin (1788–1839) published his aquatint-illustrated *A Picturesque Voyage in North America*, in 1815, in German, French, and Dutch. Svinin's multilingual book indicates the increasing international preference for aquatint as an illustration medium at this time.

In a relatively short period at the beginning of the nineteenth century, aquatint became the graphic embodiment of both the world traveler's and the print connoisseur's dream. Book and print publishers, most prominently Ackermann and Orme of London, issued from 1790 to 1840 a series of international travel views in aquatint color plate books as fine as had yet been seen.[3]

Mayer's Egypt (1804), Girtin's Paris (1803), Atkinson's Russia (1803–04), Barrow's China (1804), Daniell's India (1810), and Dodwell's Greece (1819–21) were among the many now celebrated folios that appeared in rapid succession as masterworks of hand-colored aquatint in books. Almost every country had its artistic delineator. The world, at least in aquatint, would never again look quite so well ordered, calm, and beautiful.

Aquatint's golden age continued well into the 1830s, when one of the late monuments of topographical engraving in aquatint was issued in France by Louis Garneray (1783–1857), entitled *Vues des cotes de France dans l'Ocean et dans la Mediteranée*. Garneray was both artist and engraver of this splendid series of French aquatints, which appeared in five volumes after 1830. The fifth volume, with its manuscript title *Voyage maritime*, includes in its twenty-eight views the American cities of Baltimore, Boston, New York, New Orleans, and Philadelphia. Garneray's view of New York is from one of the most popular of early vantage points of Manhattan, from Weehawken, New Jersey. Since Garneray never visited America, he must have copied the scene from similar prints.

American aquatint was therefore no isolated activity in a remote land, but part of an international topographical style that flourished in the first decades of the nineteenth century. John Hill and William James Bennett were both early artist immigrants to America at the height of this movement, who brought with them the highly sophisticated art legacy of the entire English school of topography and aquatint engraving.

Bennett in particular embodies the Paul Sandby topographical tradition, and must be seen as the artist who did the most to establish an independent American school of city view makers.

Bennett had arrived in New York by 1826 and, inspired by the American landscape, began extensive travels in his adopted land. In 1830 Bennett painted his fine pair of Baltimore views, and engraved them in aquatint the following year, the first of a series of splendid American aquatint "prospects" that would include West Point (1831), Washington, D.C. (1834), Richmond (1834), Buffalo (1836), New York (1836), Detroit (1837), New York from Brooklyn Heights (1837), Troy (1838), Charleston (1838), New York Harbor (1839), New Orleans (1841), and Mobile (1842). As a series in a consistently large folio format, the Bennett city views recall the almost contemporary aquatints of Garneray. Like Garneray, Bennett was both artist and master engraver, and also shared Garneray's skill with maritime views. The ship and harbor prospects of both artists are highly expressive of an unmistakable love of sea and harbor. Bennett also must have thought, as Garneray did, of his series of views as a collected entity in the spirit of the great English aquatint folios. But in Bennett's time, his great city aquatints were not bound up in the manner of Garneray's works or as the earlier Shaw-Hill *Picturesque Views of American Scenery* and the Wall-Hill *Hudson River Portfolio* were. As a result, although the Bennett views

have individually become the classic historic image of each of these early American cities, they have lost much of their collective identity, and have been widely scattered. They are gathered together here for the first time, after over a century, to reveal one gifted individual's serene vision of a now lost America, and well deserve a posthumous folio title page to read:

WILLIAM JAMES BENNETT

♦ ♦ ♦

THE FIRST CITIES OF AMERICA,
AS THEY ONCE APPEARED

Notes

[1] Noted in the diary of Colonel Gravatt RE, a friend of Sandby, in 1802.

[2] S. T. Prideaux, *Aquatint Engraving* (London: Duckworth & Co., 1909).

[3] The phenomenal extent of aquatint as book illustration is best recorded in the two volumes of *Travel in Aquatint and Lithography, 1770–1860* . . . (London: Curwen Press, 1956–57), and *Life in England in Aquatint and Lithography, 1770–1860* (London: Curwen Press, 1953), both describing the Library of J. R. Abbey now in the library of the Yale Center for British Art in New Haven, Connecticut.

William James Bennett: Master of the Aquatint View

GLORIA GILDA DEÁK

"An inordinate love of W. J. Bennett prints of New York grips us," wrote a reviewer in a 1940 issue of *The Art News*, reporting with undisguised ardor on his response to a small print show in a Manhattan gallery. While only three Bennett images graced that show, in the eyes of the reviewer they surpassed all others, including a fine topographic view conceived and engraved by Robert Havell, and a number of prints issued by Currier & Ives deemed "chromatically fuzzy and . . . wishy-washy."[1] By the time the review appeared, the Anglo-American artist William James Bennett had been dead for nearly a century and his existence was known to few outside a modest circle of print connoisseurs. Still, the comments aired in *The Art News* were not a revelation: encomiums had marked Bennett's career from its inception. No less elegant a London periodical than Ackermann's *Repository of Arts* was ready with praise when Bennett, whose work was hung at the Royal Academy of Arts, made his early appearances on the art scene as a watercolorist.[2] Today, as serious interest in topographic prints of the nineteenth century gains ground, and as Bennett's work comes increasingly under the scrutiny of modern sensibilities, praise for this artist is once again strong.

• • •

An introduction to the oeuvre of William James Bennett offers a fleeting glimpse into the decades of buoyant artistic activity linked to England's age of Romanticism. The paintings of John Constable, George Romney, and J. M. W. Turner were holding London audiences in thrall, while the pictorial satires of James Gillray and Thomas Rowlandson were reaching wondrous heights of irreverence. Watercolor painting was developing along spirited lines, steadily putting to flight the tenet that it was not as grand a medium of creative expression as brushwork in oils.[3] Landscapes in watercolor that captured the aerial effects of nature were

among the glories of English art. Serving and propagating the fruits of English artistic genius were illustrated books conceived by publishers like Rudolph Ackermann, William Pyne, and William Combe who entranced the public with their extravagant publications. They employed a host of artists and engravers to turn out exquisite plates in printing ventures that were brought to new and lavish levels. Many of the large-sized tomes they issued, known as travel books, were conceived as testaments to the splendors of English topography and English life.[4]

Heightened activity penetrated London's printmaking circles as well. There etching techniques were being manipulated in an effort to explore ways of acquiring the tonal effects achieved in paintings. Such a deliberately targeted aim was being made possible by a new copperplate technique introduced into England in the early 1770s, called aquatinta (aqua = water, tincta = dyed).[5] Aquatints were issued in bound volumes and as separate prints that went far toward expanding the pleasures of art while bringing it directly into the home. The English travel book took on added allure through the application of this intaglio technique, and became a prized acquisition at home and on the Continent. Bennett, whose career was launched in the tradition of the travel book, rose to the status of a master of the aquatint view.

• • •

The Royal Academy of Arts in London, nidus of William James Bennett's career, came into being under the patronage of George III, who frequently dipped into the Privy Purse to award the fledgling institution large grants. The Academy had been in existence scarcely more than three decades when young Bennett registered there as a student around 1799. Most likely he was about fifteen years old and counted on receiving seven years of schooling from among the finest instructors in the country.[6] The school was mandated to provide training in painting, sculpture,

architecture, and engraving, based heavily on a study of Greek and Roman masterpieces. Its curriculum reflected the pedagogic theories of Sir Joshua Reynolds, an Academy founder and its first president, whose knighthood on assumption of office invested the institution with a large measure of prestige. In 1792 Reynolds ceded the presidency to the American-born Benjamin West, who was at the helm when Bennett arrived.

Like all registrants at the Academy, Bennett could look forward to terms of admittance that were financially generous: for the entire seven years, instruction was completely gratuitous to those who gave proof of artistic ability at the time of declaring their candidacy. All applicants were also to present a letter of recommendation from a person of "known respectability" and were to undergo a probationary period of three months before being admitted permanently.[7] Bennett's sponsor at the Royal Academy was Richard Westall (1765–1836), a prolific artist, a Royal Academician, and an art teacher who gave instruction in drawing to the young Victoria before she ascended the throne. He was also, in the eyes of a fellow Academician, "as much entitled to share in the honour of being one of the founders of the school of painting in water-colours, as his highly-gifted contemporaries Girtin and Turner."[8] Bennett, it would seem, was in good hands from the start. Presumably the Westall sponsorship came about through family connections, but this is not documented. What we do know from a brief account written by William Dunlap is that the youthful Bennett did not subscribe to the "species of composition for which his master is most known," meaning that Westall's oils and watercolors lean heavily toward figural work—portraits, allegories, and narrative illustrations[9]—although Westall also executed landscapes. Westall taught drawing to his younger brother, William (1781–1850), and appears to have harbored both William and young Bennett in his London residence at 54, Upper Charlotte Street during the apprenticeship years at the Royal Academy of the two aspiring artists.[10] Bennett must have found a good bit in common with William since they were fairly close in age and shared the same artistic sensibilities. William, too, became a prolific painter with a decided penchant for topographic scenes.

Beginning instruction at the Academy consisted of a course in perspective, a series of lectures that included the discourses of Sir Joshua, and classes in the so-called Antique School where students were required to make repeated drawings from casts taken from the sculptural masterpieces of Greek and Roman antiquity. Later, students moved on to the more appealing School of the Living Model where they assembled for class in a small amphitheatre and drew lots for their places. The unbacked wooden benches on which Bennett and fellow aspirants sat, the formality of their attire, the kind of drawing pads they used, the ubiquitous presence of antique casts as sources of inspiration, the special lighting that was individually provided, and the classical pose of the nude model (who was required to hold the same stance for two hours with intervals of rest) are all delightfully rendered in an aquatint prepared by Thomas Rowlandson and Augustus Pugin for Ackermann's *Microcosm of London*. It brings us close to the aura of a Living Model class as Bennett must have experienced it.[11] Rowlandson, who was responsible for drawing the figures, captures in his inimitably irreverent style the expressions of alternating concentration and bewilderment on the faces of students as they attempt to enliven their drawing pads with faltering talents.

For those with demonstrated flair, one of the undoubtedly great privileges given to aspiring artists was the opportunity to exhibit their drawings and paintings in the annual exhibits staged by the Royal

Academy in Somerset House. Here, offerings of novices hung side by side with the work of artists who had already achieved fame, bringing the student's oeuvre to the notice of patrons of art and to the public at large. It was as magnificent an incentive to hard work as were the gold and silver medals annually awarded by the Academy for the best painting, the best bas-relief, and the best finished design in architecture.

In 1801, while still in his teens, Bennett had a painting accepted for hanging in the grand gallery of Somerset House. That year, Benjamin West presented nine paintings for exhibit and J. M. W. Turner a total of six. Five portraits were offered by Sir Thomas Lawrence and two each by Henry Fuseli and John Singleton Copley.[12] These, together with the latest work of a host of other distinguished artists, were presented to the public as the highest attainments of the English school. Bennett's painting, entitled *View near Melrose*, was naturally given no prominence in the Academy's crowded gallery; there was hardly sufficient space to accommodate everything of merit that was submitted. (On one occasion, West withdrew three of his paintings for want of hanging space so as to afford more opportunities for younger artists to exhibit.)[13] Bennett's painting was likely hung at the top of a wall, near the ceiling, where even the most fixed lorgnette or monocle, turned upwards, could barely discern the details. Still, for Bennett the occasion was an important one: the annual exhibits at Somerset House were designed to provide the finest display of works of contemporary art in the country, and to offer one of the best means by which members of the public could be encouraged to raise the level of their aesthetic leanings. The president of the Academy himself felt that the 1801 exhibit was of special significance. Joseph Farington, a Royal Academician who also had a painting hung that year, wrote in his diary that "West has spoken in the highest manner of a picture in the Exhibition painted by

Turner, that it is what Rembrant [sic] thought of but could not do."[14]

During the next two years, young Bennett had further paintings accepted for exhibition at the Royal Academy. In 1802 he exhibited *Dover Castle—Evening* and *Rochester Castle—Morning*; in 1803, *West Cliff, Hastings*. These titles confirm that, early on, Bennett's aesthetic sensibilities lay in the direction of landscape rather than figural painting. They also indicate to us, with their notations of "Evening" and "Morning," the young artist's concerns with atmospheric effects and the challenge they offer in handling light. Probably Bennett evinced an aesthetic for mimetic realism in topography when he first applied his pencil to the drawing pad; undoubtedly he was encouraged along these lines in the Westall household.

In the spring of 1803 Bennett was busy, in addition to his classes, executing four aquatints based on the drawings of Sir John Carr.[15] Again, the subjects are landscape views, although they did not originate with him. What is significant about these small prints (they measure approximately 3.8 x 5.7 inches) is that we meet Bennett for the first time in the artistic role for which he is most noted: that of engraver in aquatint. How he met Sir John (who was not a professional painter, nor was his work ever hung at the Academy) is not known. Possibly it was one of the Westalls who arranged the commission. Both Westalls were skilled engravers, and Richard, who had been apprenticed to a heraldic engraver in his youth, moved about with a certain authority in the printmaking world.[16]

When Bennett was ready to put his talents as an engraver into practice for such a commission as the Carr views, it was after thorough training at the Academy in the basic intaglio techniques of working on copper. The latest of these, the art of aquatint, was considered such a marvel when it was introduced into England from France

that for a time it was kept secret. In Bennett's day, the medium of aquatint was the most sought after for the illustrated books of high quality published by Ackermann, Pyne, Combe, and others; the technique had by this time been brought to near perfection, and Bennett would rapidly acquire a reputation as a skilled practitioner. Aquatint plates were used to pictorialize the three-volume text of *The Microcosm of London*, a book published in 1808 by Rudolph Ackermann that enjoyed an overwhelming success, and they were used for a host of splendid books on topography numbering into the hundreds.[17] To some of these Bennett would make a significant contribution. The aquatint technique had gained renown in England via the gifted hands of Paul Sandby, an artist and engraver of remarkably versatile talents who was ever open to experiments. No doubt a good part of his creativity in aquatint was used to provide models for the students at the Royal Academy who were attempting to master the process.[18] Probably in Bennett's day, instructors in this phase of printmaking had been originally tutored by Sandby himself.

Bennett's career at the Royal Academy was interrupted by a stint with the British Army. At the age of eighteen or nineteen, he served for a period of three or so years with the British forces. His initial assignment took him to Egypt and then to Malta; following an interval spent on leave in England, he was reassigned to the Mediterranean with the forces commanded by Sir James Craig. "Under this commander," writes William Dunlap, "Mr. Bennett visited several parts of Italy in the routine of duty, and Florence, Naples, and Rome with leave of absence. This gave him further opportunity to cultivate the art he loves, and to make drawings of scenes which nature and association render picturesque and interesting beyond most on our globe."[19]

We can imagine the exhilaration for Bennett at being ex-posed, on his assignments abroad, to the bright light and colors of the Mediterranean—a welcome contrast to the frequent grays and mists of foggy London. Then, too, he must have basked in the ample opportunities for the conception of marine scenes now presented to him under circumstances more buoyant than painting by the banks of the urban-bordered Thames. Perhaps it was here that his painterly eye first fixed itself on the sight of large ships—with their finely tuned rigging and wind-filled sails forming geometric patterns against the sky—as they moved majestically across the perpetually moving sea. But we know virtually nothing of his adventures abroad. Nor do we know how much painting he accomplished, whether he was given any drafting assignments by the Army (Dunlap hints at this), in which ways he stretched his talents, or whether he kept up a correspondence with his friend William Westall, also having a stimulating time of it overseas during the same period.[20] Undoubtedly the few topographic and marine pieces which Bennett did bring back to England (their present whereabouts are unknown) reflect his new experiences in capturing the Mediterranean light and probably document as well a decided talent for marine as well as land topography. One of these foreign scenes, entitled *View of a Franciscan Convent*, was accepted for exhibit at Somerset House in 1807 when Bennett returned to England and resumed his training at the Royal Academy. Most certainly it was executed in watercolor, a portable medium admirably suited to plein-air sketching, and one that permitted an artist to evoke the delicate tints of nature's own palette through the use of diaphanous washes.

When he returned home, the still youthful Bennett pursued his interest in watercolor with a passion that led him to bond with a small group of English artists attuned to the same reverence for the beauty of transparent color. The group formed a society in June 1807

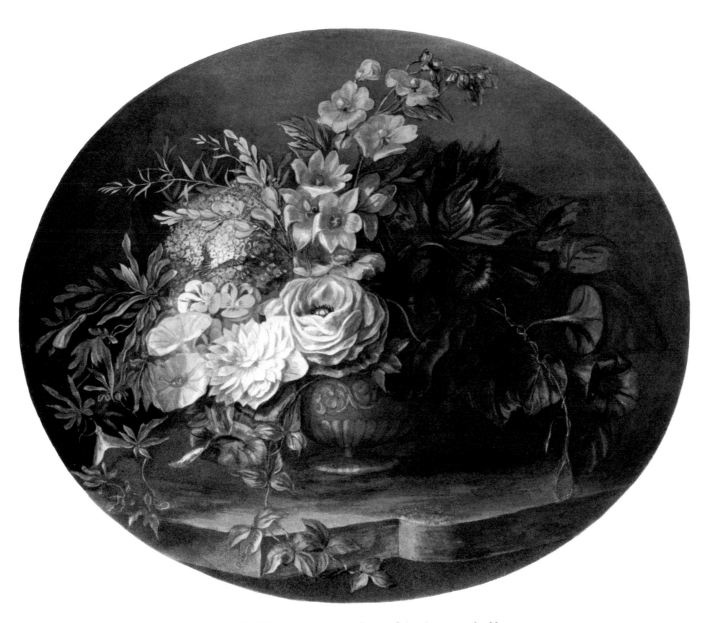

Fig. 3 [*Still life with floral arrangement*]. 1808. Colored aquatint, after Mary
Gartside. From *Ornamental Groups*. Arents Collections [checklist no. 1]

with Bennett as one of eleven charter members. They soon called themselves the Associated Artists in Water-Colours. Rooms for presenting their work to the public were taken on Lower Brook Street. When the inaugural exhibition opened in April of the following year, membership had increased to eighteen, with another eighteen listed in the catalogue as exhibitors.[21] The familiar name of William Westall is there as a member, and there are two other names, listed as exhibitors, that have significance for our story. The first is that of Mary Gartside, an ambitious aesthetician who could already claim one major illustrated book to her credit and who had just employed Bennett to work on a second (see figs. 3, 4).[22] The other noteworthy name is that of Frederick Nash, a distinguished artist with a specialty in architecture who was to marry Bennett's sister.[23]

The Associated Artists' initial presentation was not the first public exhibit of paintings in which no oils were hung. That distinction belonged to The Society of Painters in Water-Colours, a pioneering group that held its first exhibition in 1805 with a presentation of 275 pictures.[24] It was enthusiastically received. During the seven weeks' duration of the show, nearly twelve thousand people paid admission; most of the watercolors were sold. The Society's aim in insisting on an exclusivity of watercolor drawings was directed toward underscoring the distinctions between oil and watercolor art, and providing the latter a more favorable ground for appreciation than when judged side by side with paintings in oil. It was well known that in the annual exhibitions of the Royal Academy at Somerset House, the best gallery in that building (there were several) was reserved solely for paintings in oil. Watercolors, generally kept small in size because of the accommodation and expense of glass, were hung in the subordinate galleries; still, they were usually outnumbered and were at an obvious disadvantage in the

view of the fairest of judges when opposed on the walls to "half an acre of canvass [sic], covered with the strongest tints, enriched with the most gaudy colors, and glazed with a varnish calculated to heighten the already too powerful effect."[25] It was with great expectations, then, that the Society opened its first show in galleries at 20 Brook Street to flaunt an art which sought its basic appeal in the use of transparent pigments. A pictorial record of one of their exhibitions (in galleries later leased on old Bond Street) is preserved for us in a lively aquatint conceived by Thomas Rowlandson and Augustus Pugin, and published in *The Microcosm of London*.[26] The Society was to undergo a change of name, and indeed of aims and of fortunes, but eventually, in 1881, it became the Royal Society of Painters in Water-Colours under the patronage of Queen Victoria.

The Bennett circle of watercolorists were careful in avowing at the outset that they entertained no hostility toward this pioneering Society. They simply felt that there was room for two organizations devoted to an art that was fast gaining an appeal, and said so in their catalogue: "The rapid advance which this class of art had made, its powers of reaching greater excellence, if judiciously employed, and the propriety of separating drawings and pictures in water-colours from the immediate contact of those produced with other materials, were probably the motives for forming that society; the same opinions, the same feelings led to the association of the artists, who now, for the first time as a distinct body, submit their works to public inspection."[27] Membership in the Associated Artists was not held to a limited number, as it was in the Society, and female members were given the right to vote on all occasions. This tribute to the capacity of women artists was, like the first innovation, a distinct advancement. The coexistence of the two bands of watercolorists was lauded by *The Microcosm of London*, which ex-

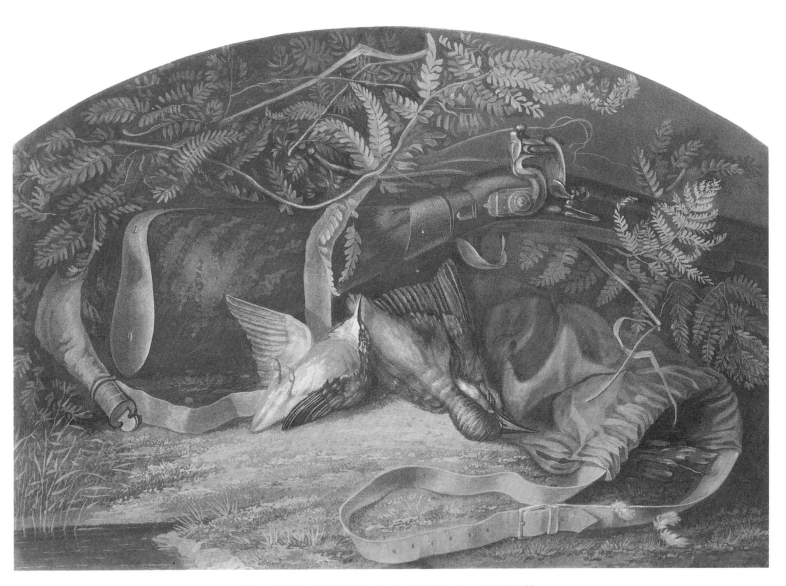

Fig. 4 [*Still life with dead birds and gun*]. 1808. Colored aquatint, after Mary
Gartside. From *Ornamental Groups*. Arents Collections [checklist no. 1]

pressed the opinion that gallerygoers should be fed variety as well as excellence. "In every point of view the public are benefited by this rivalship," ran the commentary, "and are certainly much indebted to the spirit of the first projectors, for a plan which is likely to prove ultimately beneficial to the artists and to the country."[28] For five years, Bennett presented watercolors to be hung and sold in the Associated Artists' shows and, in the years 1811 and 1812, he served as treasurer. There were some who felt that the grand showings at Somerset House suffered because of the independent stance of the two groups of watercolorists; in 1810 members of the Royal Academy felt sufficiently threatened by the popularity of these secessionists—who had opened up the only other public spaces where artists could show their work at the time—to repeal the clause excluding watercolor painters from membership.[29]

Bennett's ardent involvement in watercolor painting, his skills as an aquatint artist, and his propensity for landscape were intimately tied to one another. During the early phase of this artist's career, the art of watercolor was being brought to an exalted level of achievement in England, principally by artists like Thomas Girtin, J. M. W. Turner, and Bennett's mentor, Richard Westall. The specialty of Girtin and Turner was the topographic view. All three earned for the art of watercolor the same dignity accorded work in oil, as well as securing for it an unshakable place in popular affection. To a large extent, English watercolor painting evolved out of the Dutch monochrome tradition where artists registered a particularly sensitive response to considerations of light and atmosphere in the conception of landscapes. When Girtin and Turner took up these aesthetic challenges with watercolor techniques, they brought English landscape painting to a domain of poetic topography. The beauty of the English rural scene became a noble subject for artists. And their tableaux in this genre achieved an ever-widening following through the reproductive process of the aquatint, a technique that sought to emulate the tonal appeal of watercolors. As Bennett and his contemporaries worked to hone their skills in techniques that served their aesthetic sensibilities, they helped to create an artistic climate in which the vogue for landscapes was steadily disturbing the hegemony of portraitists.

Two years after Bennett joined the band of watercolorists, his abilities as an artist came to public attention through the pages of Ackermann's *Repository of Arts*. In a critique of the exhibition staged by the Associated Artists in 1810, it was commented that "among the marine pieces, a View of Stromboli, by Bennett, is worthy of distinction. The waves have a freedom and swell very rarely effected in watercolours, and the bearing of the vessel is well produced."[30] This brief encomium takes on larger significance when we consider that the anonymous English reviewer was particularly sensitive to marine pieces; he appears to have been on the lookout for an unofficial iconographer of England's maritime glory: "in a country so mighty and unrivaled in naval power," he puts forth, "it is singular that there should be so few marine painters."[31] Bennett evidently evinced his dexterity in handling water and ships in his projection of Stromboli, a spot of land flung far out into the sea off the northern coast of Sicily. He conceived it during his stint with the British forces in the Mediterranean under Sir James Craig, and brought it back with him to England either as a finished watercolor or as a preparatory drawing, satisfied that the composition was acceptable for public viewing.

Again, in 1812, Ackermann's reviewer took special notice of Bennett's handling of water in a picture entitled *Rochester Castle*. "A fine breadth of effect pervades this picture," begins the critique, "the massive castle is boldly relieved upon the sky; the water is smooth and

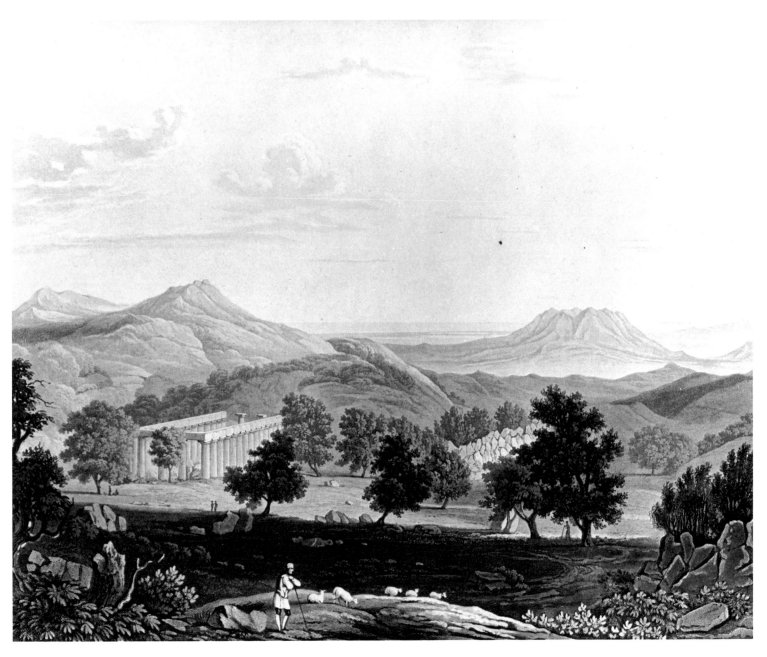

Fig. 5 *A North-west view of the temple of Apollo Epicurius.* 1819. Aquatint,
after James Foster, Jr. From *Ancient Marbles in the British Museum*. Art and
Architecture [checklist no. 5]

pellucid, reflecting upon its expansive bosom the surrounding objects with great truth to nature. The scene which we have ever thought worthy the study of a painter, is pourtrayed [sic] with fidelity and completed with an extensive display of the knowledge of art."[32] This level of praise again underscores Bennett's facility in handling marine pieces and stamps him as a mature artist: he is extolled for his mastery of the architectural details of the famous Rochester Castle (a historical landmark located about midway between London and Canterbury), for his convincing projection of the liquid quality of water, for the fidelity of his representational draughtsmanship, for his success in competing with the similar efforts of other artists, and, most important, for that extra artistic dimension defined by the reviewer as "a fine breadth of effect."

Bennett was now twenty-eight years old, with his training at the Royal Academy about five years behind him. It was there that he had acquired his "extensive knowledge of art" in highly disciplined classroom instruction where he was forced to spend endless hours, year after year, copying, copying, copying. Like many of his peers, he had gained a remarkable dexterity in the faultless handling of perspective, and a firm grasp of the many basic compositional elements indispensable to landscapes, seascapes, townscapes, and interiors. It is true that he won no gold or silver medal at the Academy (accorded biennially), but then his specialty made him ineligible to enter the intense competition for either prize. Medals were not offered for watercolors; they were awarded for oil paintings in which the artist manifested a strong dexterity in figural work, a skill highly prized in most artistic circles of England, especially at the Academy during Bennett's years of apprenticeship. The aquatint rendering of a Royal Academy exhibit by Rowlandson and Pugin for *The Microcosm of London* tells the story: there, more than three-quarters of the paintings hung for public viewing, and paraded as

England's best, are portraits or historical paintings.[33] Bennett's figural work can be said to be competent but without inspirational flair. The forms peopling his landscapes are conceived without particular physicality or psychological intensity. Although he did execute an occasional likeness, the human figures in his compositions are subordinate elements; they are generally formal and conventional in movement, and not calculated to detract from the importance of a topographical subject. Both the gold and silver medals given out by the Academy were, as stated in the rules, for the best historical picture in oil colors consisting of not less than three figures; the principal figure was to attain a height of at least two feet, and the overall size of the picture was to be somewhat more than three by four feet.[34] In addition to the demanding figural work, Bennett was unaccustomed to working up a canvas of such large proportions: both the size of a watercolor and the plate for an aquatint are comparatively much smaller. During his years at the Academy, the coveted gold medals were awarded for large allegorical compositions: Thomas Douglas Guest's *Bearing Dead Body of Patroclus to the Camp* (1805) and Lascelles Hoppner's *Judgment of Solomon* (1807).[35] Eventually, a Turner Gold Medal was created, in fulfillment of the wishes of the artist, for the best student landscape. This did not come about until 1857, however, half a century after Bennett's time.

It may have been on the recommendation of his tutors at the Royal Academy that Bennett received a commission, around 1811, to execute two plates for the British Museum's catalogue of ancient marble sculptures held in its department of Greek and Roman Antiquities. The two aquatints are entitled *A North-west view of the temple of Apollo Epicurius, and of the surrounding country* (plate XXVI) (fig. 5) and *A near view of the same temple, seen from the north-east* (plate XXVII).[36] Both are after images by John Foster, Jr. (1787–1846). Work on the catalogue had

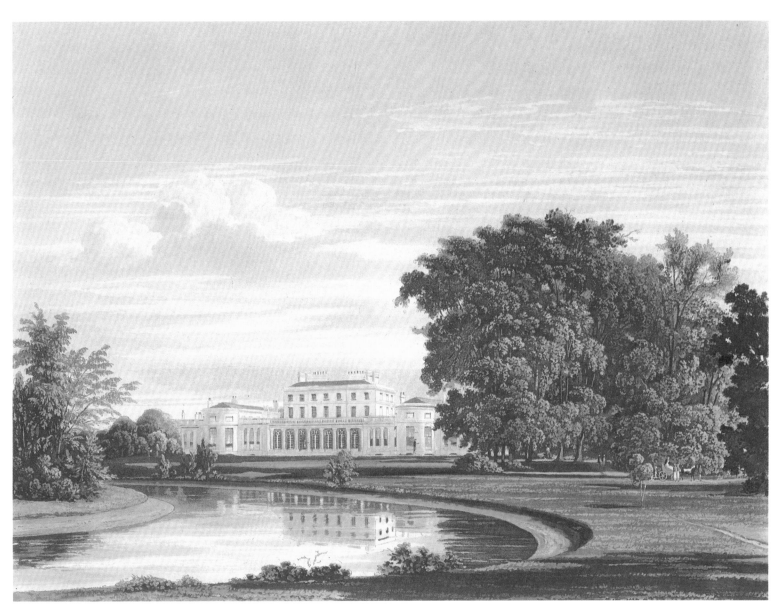

Fig. 6 *Frogmore.* 1819. Colored aquatint, after Charles Wild. From *The History of the Royal Residences.* Print Collection [checklist no. 4]

followed a printmaking assignment on the sumptuous two-volume edition of Ackermann's *A History of The University of Oxford, Its Colleges, Halls, and Public Buildings*. Again, Bennett was asked to execute two plates, both of which appeared in volume two and were based on the drawings of his friend William Westall.[37] The plates are of Christ Church Cathedral, an interior with no figures (except for one oval portrait high on a marble column), and of Jesus College Chapel, an interior with three conventional figures. Throughout the two volumes, the plates (there are about eighty) are uniformly high in quality, if not decidedly exquisite. Ackermann's stated aim was

> to produce a History of Oxford in a superiority of form, and with a style of graphic illustration, hitherto unknown to a subject so worthy of the one and so susceptible of the other. Indeed, such is the celebrity of its character, the superb appearance of its figure, and the attractive display of its component beauties, as to create some degree of surprise, that such a work is now for the first time offered to the public.[38]

The text was prepared by William Combe, and although it was well researched and gracefully styled, the publisher felt that the writer should resign to the artists of the two volumes "the larger and undivided portion of approbation due to their talents."[39] The recitation of some of the names involved in the drawings and the engravings—Augustus Pugin, Frederick Christian Lewis, J. Bluck, Daniel Havell, John Hill, J. C. Stadler, Frederick Mackenzie, Thomas Uwins, John Samuel Agar, and, of course, William Westall—indicates that Bennett was working in collaboration with artists of eminent stature in their particular fields. Pugin, for example, was unparalleled as an architectural specialist; Lewis was admired by John Ruskin for his figural and animal work; while Thomas Uwins contributed the appealing full-length portraits required for the volumes. A few of the names would present themselves more than once in association with that of Bennett. The appearance here of John Hill is

significant: he would precede Bennett to America, work with him there on occasion, and harbor him in the last year of his life.

Another lavish publication of England's Romantic Age that called on the art of the aquatint for its illustrations was William Pyne's *The History of the Royal Residences of Windsor Castle, St. James's Palace, Carlton House, Kensington Palace, Hampton Court, Buckingham House, and Frogmore*. Bennett was engaged on this three-volume work over a period of four years beginning in 1816; it was his most extensive book assignment. For it he turned out eighteen plates, based on the images of James Stephanoff, Charles Wild, and George Cattermole.[40] They show Bennett at his early best. (See figs. 6, 7.)

During these years Bennett also worked on William Combe's *The History of the Colleges of Winchester, Eton and Westminster* and on James Ralfe's *The Naval Chronology of Great Britain*. The latter book, for which he did only one plate, must have given him great satisfaction in his role as marine artist. Entitled *Sir W. Hoste's Action off Lissa*, the aquatint represents a strong naval portrait of six British frigates in action at the moment of firing guns. (In the battle of Lissa in the Adriatic on March 13, 1811, a Franco-Venetian squadron attempting to imitate the tactics of Nelson at Trafalgar was defeated by a smaller British force under Captain [afterwards Sir] William Hoste.)[41] A large expanse of sky—delicately rendered—provides a backdrop against which the ships are silhouetted. Again, there is a convincing sense of the liquid, lapping quality of the water, of air billowing the sails, and of the anatomy and force of the vessels, the whole wrapped in a wash of light.

In all of his work for the book publishers, Bennett could count himself a participant in an energetic circle of watercolorists and engravers based in London. Meanwhile, however, the Associated Artists in Water-Colours, which he had helped to found, was no longer in

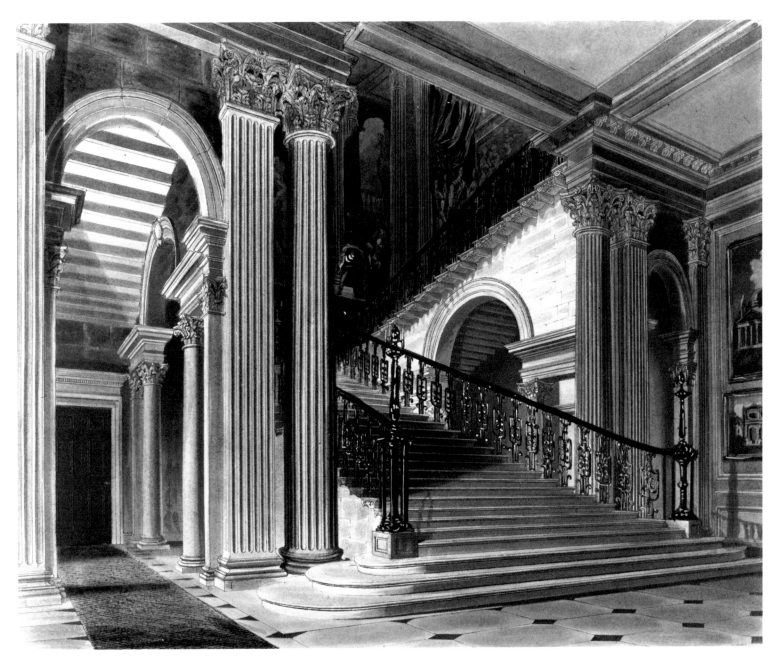

Fig. 7 *Stair Case Buckingham House*. 1819. Colored aquatint, after
R. [sic] Cattermole. From *The History of the Royal Residences*.
Print Collection [checklist no. 4]

existence. Increasing financial difficulties had mounted to the point where in 1812 (its fifth year), the contents of the gallery in which its last exhibition was held were seized by the landlord and sold to pay the rent.[42] Bennett must have regretted the demise of a professional unit he had helped to create. Still, he had profited by his association with fellow artists: his work had gained in stature, and he had made contacts leading to commissions that were professionally rewarding. In 1819 he was to have the satisfaction of being accepted as an exhibitor with the original, and more prestigious, watercolor society (The Society of Painters in Water-Colours). In each of the next seven years he presented original compositions to be hung for public viewing under these new auspices.[43] This group, too, had had its reverses, financial and otherwise; its members had decided in 1813 that it was perhaps best to include oil paintings in their shows in order to attract larger paying audiences. When Bennett was signed on, the group was called The Society of Painters in Oil and Water-Colours. This was, of course, a situation that vitiated the very purpose for which the group had been created, and in 1820 a resolution was passed to revert to the original name and to the exclusive posture of the Society.[44]

Surprisingly, Bennett seems to have entered the activities of the reconstructed Society with less than ordinary zeal. Exhibition records show that he presented a total of only seven watercolors in seven years as compared with his contribution of more than forty watercolors in the five years of his charter membership with the Associated Artists in Water-Colours.[45] The seven appear to have been based on compositions conceived during his tour of duty in the Mediterranean and thus represent no new work. As a matter of fact, "this Associate exhibitor merely fluttered about the Society for some half-dozen years, during which time he hailed from four different places of address," complains J. L. Roget, one of the Society's principal chroniclers, in assessing Bennett's contributions.[46] In the absence of any enlightening documents or letters, the remark is perplexing. Roget continues: "In 1826 his [Bennett's] name disappears from the catalogue, and nothing is recorded of him after that date."[47]

By 1826, Bennett was settled in America. The following year he presented two landscapes at the annual exhibition of the National Academy of Design in New York.

WHEN BENNETT SET SAIL for America, the extent to which he could size up the prospects for a successful artistic career on this side of the Atlantic was prescribed, in large part, by the experiences of a host of English artists who had settled here earlier. Art in America had been slow to take root; by the beginning of the nineteenth century, it was far from moving toward that "enviable degree of perfection" so effusively claimed for England by Mary Gartside.[48] As late as the 1830s, the cultural press was still lamenting that America lagged behind Europe, not only because of a lack of teaching academies and exhibition places but also chiefly, it was believed, for want of public and private patrons. "Is it not high time," the *New-York Mirror* demanded, ". . . that in our own country, whose literature is acquiring her a name among the nations of the earth, national patronage should be extended to the fine arts? . . . And are there not as many subjects for the pencil and chisel in our land, as beneath the sunny skies of Italy?"[49] Still, art had created its place in the new society, and in the early decades of the young republic, when Bennett entered the scene, it was enjoying the discovery of America as a fresh source of ideas and imagery that defined a new beauty.

Europeans, particularly English artists, who shared in the discovery were among the first to create topographic albums of sites in the New World that provided a systematic record of this imagery. They set about this with an eye to the print market, preparing their views for circulation in multiple impressions as engravings, aquatints, or lithographs. The marketing and public consumption of prints in America was on the rise, and within the print trade, European techniques and practitioners were providing fundamental support in the yield of multiple images mirroring the American scene. Printmaking projects that were conceived to celebrate the distinctive charms of the New World's natural surroundings culminated in *Itinéraire pittoresque du fleuve Hudson*

(1816–23; published 1828–29), *Picturesque Views of American Scenery* (1819–21), and *The Hudson River Portfolio* (1820; published 1821–25), while an album of Philadelphia views issued earlier, in 1800, had focused tribute on the urban glory of a colonial settlement that had "been raised, as it were, by magic power, to the eminence of an opulent city."[50] Ambitious projects of this kind, involving a series of images undertaken to document topographic beauty, had little precedent. Three of the most notable pictorial series ever to bear on the American scene were of another, distinct genre. The first, prepared by Jacques Le Moyne de Morgues in 1564, was a colonial assignment for Charles IX of France; the second, undertaken in 1585 by the artist John White, was an ethnographic mission initiated by the ambitious Sir Walter Raleigh; and the third, known as *The Atlantic Neptune*, was commissioned just prior to the Revolution for the intelligence purposes of the British Admiralty.[51] No such colonial or political motives were behind the topographic albums, again conceived by Europeans, that were issued in the first quarter of the nineteenth century. The emphasis was now on the painterly transcription of the landscape, an aesthetic course that was a direct inheritance from England, and one to which the art of her former colony would be forever indebted. England at this time was producing many of the finest topographic albums ever conceived in the Western world, and the devotion of some of her most brilliant artists to landscape was acquiring for her a leading role on the Continent as the arbiter of new directions in art.[52] Such an inheritance provided America with an artistic focus other than portraiture and historical painting. The latter, for so long in vogue, was less suited—with its requirements of official patronage and a long history—to the developing art of a new republic.

Three of the topographic albums undertaken on this side of the Atlantic originated with British artists whose views were executed

as engravings or as aquatints. The fourth, *Itinéraire pittoresque du fleuve Hudson*, was planned by Jacques Gérard Milbert, a Frenchman, using lithography. Of the four albums, *Picturesque Views* was intended to be the most topographically wide-ranging, and responsible for it was Joshua Shaw (ca. 1777–1860), a prolific English artist who had frequently exhibited at the Royal Academy of Arts. It was not long after he settled in Philadelphia in 1817 that he fell under the enchantment of America's wilderness, writing in the preface to his album that "In no quarter of the globe are the majesty and loveliness of nature more strikingly conspicuous than in America."[53] Shaw did not find the prior talk of America's splendors the least bit exaggerated. Little of the landscape had found its way to any artist's canvas, he noted, a situation unlike that in England, where every site of picturesque charm had, according to a London fine arts periodical, "been 'booked by the graphic tourist' over and over again."[54] He came to the mission of documenting America bolstered by years of practice in the tradition of English romanticized settings. The quiet charm of his pioneering work gave to native artists an increasing awareness of the unending beauty of their new land.

A similar contribution was made by the Irish artist William Guy Wall through the watercolors he conceived for his *Hudson River Portfolio*, painted by him "in his best Manner, with a faithful attention to Nature." They were to be engraved "in Aquatint," he announced, "in a manner peculiarly adapted to represent highly finished drawings."[55] They constitute one of the finest collections of New York State views ever published. Like Shaw and other landscapists with English training (George Beck, William Groombridge, Francis Guy, and William Winstanley among them), Wall helped to raise the level of topographic painting in America. Indeed, it can be said of this group of artists pioneering in landscape art that they laid the groundwork for the later

marvels of the Hudson River School.[56]

Many of the Anglo-American artists of the time were involved in the printmaking trade, where English practitioners of the art of aquatint were dominant. When Bennett joined the group, he was to cap an era that has been termed the Golden Age of aquatint art in America.[57] Prior to Bennett's arrival, the aquatint artist who could claim first place was John Hill (1770–1850), a Londoner who had settled in Philadelphia in 1816 and then moved to New York. His output was prodigious.[58] Hill had been engaged by Joshua Shaw to work up the plates for his *Picturesque Views of American Scenery*, and he was subsequently chosen to collaborate with William Guy Wall in executing the aquatints for his *Hudson River Portfolio*. Concurrently with this latter project, he was busy on his own *Drawing Book of Landscape Scenery*, a manual containing aquatint illustrations that proved quite popular. The *Portfolio* and the *Drawing Book* were sponsored by Henry Megarey, a New York stationer turned publisher, who was to be important in advancing Bennett's American career. Bennett and Hill were known to each other: both had worked as engravers in aquatint for Ackermann in London. It may even be that Hill paved the way for Bennett's emigration, though there is no documentation to support this. It seems likely, however, that it was Hill who led Bennett to the energetic circle of English artists working here, and who introduced the younger engraver to Megarey, the first American entrepreneur to sponsor Bennett's work. Within a year of settling in New York, Bennett brought his talents to bear on *Megarey's Street Views in the City of New-York*.[59]

The aquatint that served to introduce Americans to the oeuvre of William James Bennett presented him in the tandem functions of artist and engraver, the first occasion we encounter him in this dual role. Entitled *Broad Way from the Bowling Green* (fig. 8), the aquatint is as

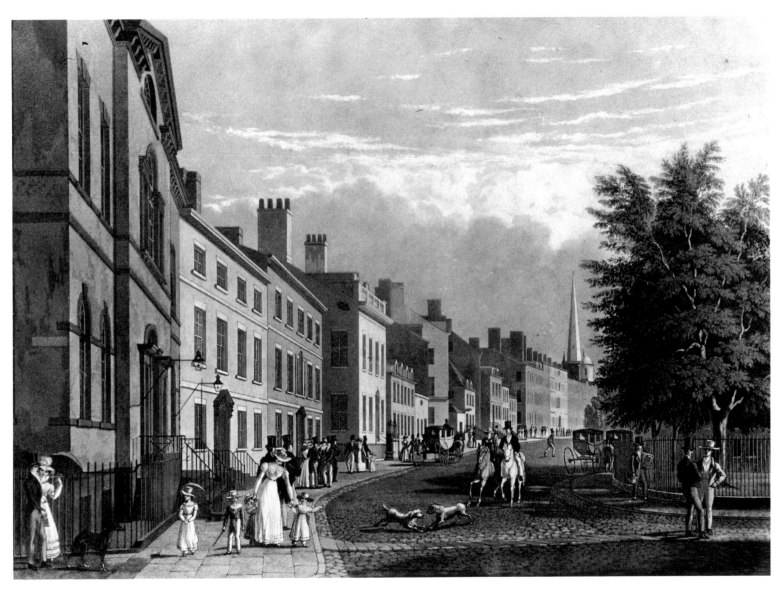

Fig. 8 *Broad Way from the Bowling Green*. ca. 1834. Aquatint.
Emmet Collection, Print Collection [checklist no. 8]

sparkling a presentation of an urban thoroughfare as ever stepped from the pages of a London travel book. New York is shown at her best. For his radiant presentation, Bennett chose a line of handsome residences that flanked Broadway looking north from the Battery just opposite Bowling Green Park. He designed a strong architectural motif to frame the image at the left and set up a pleasing circular rhythm throughout the composition via parallel curves that converge in the distance at Wall Street. There the spire of Trinity Church pierces the air. The curves lead the eye by following the line of buildings, the bend of the thoroughfare, and the circular turn of a park railing. Lending another pleasing touch are the fashionable New Yorkers who animate the townscape. Bennett has them make their way along Broadway astride mounts, in private coaches, or on foot in the open sunshine of a summer's day. An aura of optimism pervades the scene (probably drawn in 1826), and rightly so, for only recently the city had been host to the ceremonies opening the Erie Canal and looked forward to an era of increasing prosperity.[60]

Bennett's rendering was not without prototypes. A close model for it is the anonymous *Leicester Square from Leicester Place* (fig. 9), published in the *Repository of Arts* of January 1, 1812.[61] The meticulous attention there to architectural notation, the curvilinear motion of the composition, the placement of the figures, the welcome intrusion of a small park, and the technical achievement of rendering the design in aquatint are all recognizable precedents that served Bennett well.

The Broadway view was followed by two other profiles of Manhattan which Bennett executed as part of the Megarey street views: *South St. from Maiden Lane* (fig. 10) and *Fulton St. & Market*. Executed around 1828, they turn to the commercial rather than the fashionable aspects of the city.[62] In the 1820s, South Street on the East River had become one of the lively commercial hubs of the city. The insurance companies of Wall Street, the warehouses of Pearl Street, the markets of Fulton Street, and the splendor of Broadway all contributed to the blaze of activity on South Street. Bennett leads us to the waterfront where majestic sailing packets to the left and countinghouses to the right embrace the cargo of a vigorous trade. Even the cobblestoned street that Bennett depicts had not existed before the turn of the century. It was made of landfill, by city order, to plump the southern contours of the city and to accommodate the burgeoning commerce. This view also gives a hint of the artist's prowess in marine portraiture. He has depicted the intricate armature of the many ships, and the complex webbing of their rigging lines, with the same careful notation given to the architectural motifs of the opposing buildings. He has also made clearly legible, on the sailing packet nearest us, the name *Leeds*, a reminder of the prideful comment that "Such is the enterprising spirit, the commercial knowledge, and liberal conduct of British merchants, that their ships are welcome visitants to every part of the globe where winds can waft and waves can bear them."[63] Reflections of this kind, which appeared in *The Microcosm of London* and which Bennett certainly read, must have helped him to adjust to life in a distant city heavily tied to British trade.

The view of *Fulton St. & Market*, evocative of the aquatint of *Billingsgate Market* (1828) published in *The Microcosm of London*,[64] depicts the Manhattan market that had been erected earlier in the decade on the north side of Fulton Street, facing the East River. Here Bennett turns our backs to the ships along the waterfront and directs our gaze along the broad expanse of Fulton, a street running perpendicular to the river above the South Street view. At the left, he features the line of elegant Georgian buildings used for trade, which have been largely preserved; they are known today as Schermerhorn Row. At the right, he pictures the block-long Fulton Market. Crates, barrels, and single-

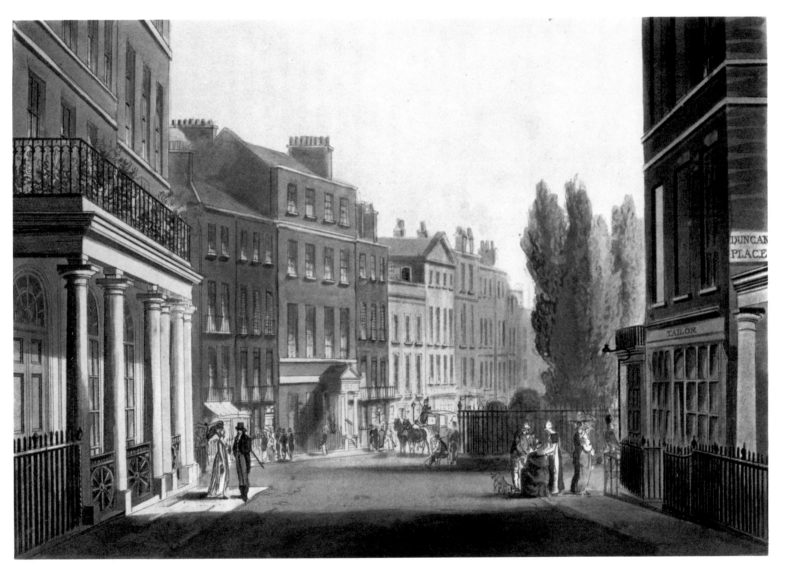

Fig. 9 Anonymous, British. *Leicester Square from Leicester Place*. 1812.
Colored aquatint. From *The Repository of Arts*, vol. III. Print Collection

and double-wheeled carts, together with a street population made up of workers, tradesmen, and merchants, are part of the comings and goings of merchandise, and attest to the market character of the neighborhood. Beyond the reportorial content of the print, the eye deciphers the tonal qualities that Bennett could command through the process of aquatint. No trace of coarseness is detected in the high vault of sky, and, further, we note the deft control he exercised over the repeated bitings of the plate to achieve the gradations that characterize his cloud formations.

Working on documentary prints such as those commissioned by Megarey afforded Bennett a direct entry into the life of New York; unfortunately, this particular printmaking project was short-lived. It had been Megarey's intention to issue four numbers of three New York views each, but apparently only the first number appeared.[65] That such projects were risky because of unexpected costs, lack of public response, or discontinued fervor on the part of the publisher is corroborated by the failure of both *Picturesque Views* and *The Hudson River Portfolio* to attain stated expectations. Interestingly, Megarey (in association with two other booksellers) had been involved in the publication of the *Portfolio*. Despite the truncation of this latter project, his willingness to enter into another printmaking venture clearly reflects his appreciation of Bennett's talents. The Megarey-Bennett collaboration would be fairly extensive.[66]

Bennett's debut on the New York art scene coincided with the inauguration of the National Academy of Design (NAD), an institution that was to play a central role in his life. It was America's answer to the Royal Academy in London and, in this sense, provided Bennett with a certain continuity in his artistic heritage. Founded in 1826, the presumed year of Bennett's transatlantic crossing, the NAD was the

most important art institution in America for much of the nineteenth century.[67] Among its founders were Samuel F. B. Morse, William Dunlap, Asher B. Durand, and Ithiel Town who formed the NAD in reaction to the unprogressive policies of the American Academy of Fine Arts (1801–40). Early members included Rembrandt Peale, Thomas Cole, Hugh Reinagle, and Henry Inman.[68] The NAD helped to make New York the artistic center of the country, chiefly through its training of students as well as through its annual spring exhibitions, which fostered the most advanced American art. For the inaugural exhibition, the Governor, the Mayor, the faculty of Columbia College, and a host of city officials were invited to a private opening, as were members of the American Academy of Fine Arts, who expressed open hostility. Predictably, the works on display were assailed by severe criticism in the conservative press, and some of the founding principles of the NAD were attacked.[69]

Bennett was ready to present work at the Academy's second annual exhibition when it opened May 17, 1827. Receipts for its seven-week run exceeded those for the first exhibition and even left a small balance in the treasury.[70] In his first Academy showing, Bennett presented two untitled landscapes. Both were presumably watercolors, although only one was so designated in the exhibition records.[71] Like many of his original pieces, their whereabouts are unknown. In the exhibition of 1828, the London-trained artist showed seven works, six of which had been executed prior to his coming to America; the seventh was *North River Sloops, Duane Slip, New York*. Of the foreign paintings that the artist brought with him, four were indicated as having settings in England; the other two, of the Mediterranean area, dated from the time he served with the British Army.

Bennett had a fairly consistent exhibition record at the Na-

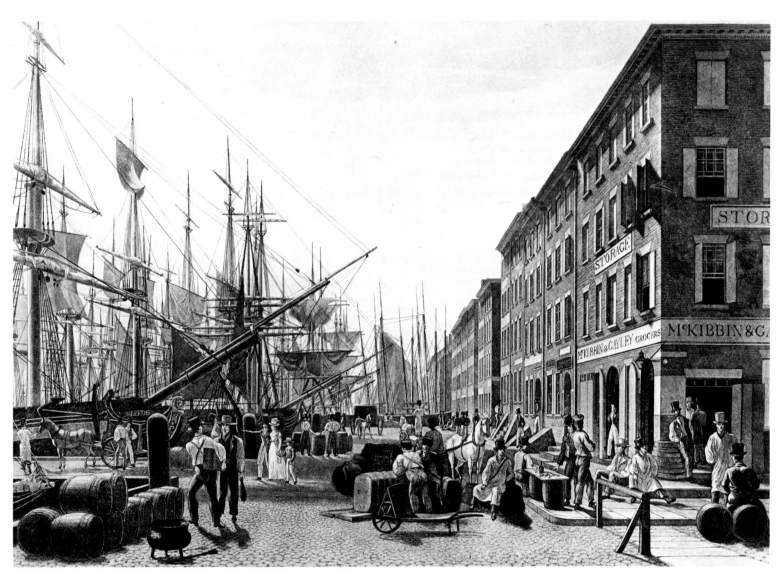

Fig. 10 *South St. from Maiden Lane.* ca. 1834. Aquatint.
The Phelps Stokes Collection, Print Collection [checklist no. 9]

tional Academy of Design during the American phase of his career. From the time of his first showing until 1843, the year before his death, his name fails to appear only five times.[72] On the occasions when he presented more than three works, a European landscape was invariably among them. At one early exhibit, he presented an aquatint of a Cheshire peasant based on the design of his mentor Richard Westall. By 1829, Bennett was a full-fledged member of the Academy, having been elected to associate membership two years earlier.

In 1830, a new dimension was added to Bennett's association with the National Academy of Design: he was made Keeper, a post in which he served for nearly ten years.[73] His duties were to follow closely those laid down in the constitution of London's Royal Academy:

> There shall be a Keeper of the Royal Academy, elected by ballot, from amongst the Academicians; he shall be an able painter of history, sculptor, or other artist, properly qualified. His business shall be to keep the Royal Academy, with the models, casts, books, and other moveables belonging thereto; to attend regularly the Schools of Design during the sittings of the students, to preserve order among them, and to give them such advice and instruction as they shall require; he shall have the immediate direction of all the servants of the Academy, shall regulate all things relating to the schools, and, with the assistance of the visitors, provide the living models, &c. He shall attend at the exhibition, assist in disposing the performances, and be constantly at hand to preserve order and decorum. His salary shall be one hundred pounds a year; he shall have a convenient apartment allotted him in the Royal Academy, where he shall constantly reside; and he shall continue in office during the King's pleasure.[74]

Bennett did not receive a salary, however; he was promised remuneration when the finances of the NAD registered a healthy level. Meanwhile, he was to accept, as compensation, lodgings in Clinton Hall at Beekman and Nassau Streets where the Academy had established its first home on the second floor.[75] These terms were apparently quite satisfactory,

and from that time, Bennett had a full career as teacher and custodian. On the one hand, the double post kept him tied to New York and curtailed his travels. On the other hand, it placed him, most desirably, at the center of the American art scene.

Bennett's acclaim as a watercolorist was, meanwhile, steadily gaining ground. We learn this from the *New-York Mirror* in its comment on a Manhattan seascape entitled *Hay Sloops, Duane Slip*, presented for exhibition at the NAD in 1831: "The great reputation which Mr. Bennet [sic] has already obtained in this kind of painting will, we hope, prevent the visitor from passing over his pieces carelessly. This is one of superior merit. It shows like a reflection of the real scene in a camera obscura. It has everything of nature but sound and motion."[76] Two other landscapes presented that year, with settings in New Jersey and Pennsylvania, indicate the extent of the artist's travels outside of Manhattan. One is entitled *Weehawken, from Turtle Grove*; the other is *The Falls of the Sawkill, near Milford, Pike County, Pa.* Both of them are cited as "Painted for a work published by Durand & Wade." The views were undertaken in collaboration with Asher B. Durand, a prominent engraver before he abandoned printmaking to become a leading painter of the Hudson River School. They were engraved on steel plates and are among the illustrations that appear in William Cullen Bryant's *The American Landscape*, a publication project proudly heralded in the *New-York Mirror* as representing American art and literature at its best. Bryant, one of the leading poets of the day, was to provide the letterpress for a series of ten volumes containing six prints each, while landscape artists of established reputation would be called on to present topographic scenes. "To those who are fond of the charms of nature in all her grandeur, loneliness, and magnificence, as well as in her softer features; to those who feel their hearts warm and expand at the contemplation of *American* scenery,

Fig. 11 *Niagara Falls . . . View of the British Fall, taken from Goat Island.* 1830.
Colored aquatint. Print Collection [checklist no. 16]

pictured by American artists, and embellished by American writers, we warmly recommend this production. It would reflect disgrace on the taste as well as the patriotism of our countrymen were it to fall to the ground for want of patronage."[77] But it did fall to the ground. Here was yet another printmaking project that was curtailed for want of subscribers: only one number was ever published. Contributing artists to that first volume were Durand himself, Robert Weir, and Thomas Cole, all landscapists attached to the NAD. Durand's steel engravings of the Bennett designs, printed by Elias Wade, Jr., were later reproduced in two 1833 issues of the *Mirror*, attended by descriptions of the plates.[78]

A trip taken in 1829 to Niagara Falls resulted in some of Bennett's truly spectacular work in America. His images of the Falls drew this accolade in the press: "We have seldom met, among the numerous delineations of this stupendous wonder of nature, any conveying a more forcible impression. The sweep of the immense body of water over the precipitous ledges of rocks — the volumes of foam floating away with the breeze, and every thing but the deafening thunder, are represented to the life. These prints would form valuable *morceaux* for travellers from Europe, desirous of carrying home with them correct sketches of American scenery."[79] The Niagara Falls, as a subject for art and for literature, were an unceasing source of pleasure to the nineteenth-century public, for whom artists produced a staggering array of images. In *Niagara Falls: Icon of the American Sublime*, Elizabeth McKinsey traces the iconography of the cataract, following its shifting images and meanings from the seventeenth-century rendering accompanying Father Louis Hennepin's account to modern times. She singles out an 1830 image by Bennett (*View of the British Fall, taken from Goat Island*) (fig. 11) as one of the most famous of the time. "Many artists imitated this appealing print," she writes. "Victor de Grailly copied it in at least

two paintings, and Regis Gignoux created a lovely painterly version of it."[80]

Bennett executed four views of Niagara Falls, two of which were rendered in aquatint by the able John Hill (figs. 12, 13), while two were made into aquatints by the artist himself (figs. 11, 14). All four were published by Henry Megarey and were clearly an outstanding success.[81] It was undoubtedly satisfying to Bennett that his Niagara aquatints circulated also as lithographs. Popular interest in the spectacular scenery of Niagara Falls encouraged artists to make lithographic reproductions of engraved compositions. Because lithography was the least costly printmaking process, these prints could be made available to a wider public. Two lithographs after the Bennett-Hill aquatints of the Falls were prepared by Gerlando Marsiglia, an Italian-born artist who was one of the National Academy of Design's founders. In recognition of the caliber of the original models, Marsiglia followed them closely in design, although some loss was inevitable. Neither the strong luminous quality nor the chiaroscuro effects that were realized in the original Niagara views are present in the lithographs. But the somewhat grainy effect achieved on the stone by the lithographer Anthony Imbert is not without appeal.[82]

It is another measure of Bennett's success at this time that one of the paintings he brought over from London was purchased by Philip Hone; the watercolor (whereabouts unknown) is entitled *Castel à Mare, Bay of Naples*. "A lovely thing," the *New-York Mirror* murmured when it was presented in 1832 for exhibit, along with two Niagara scenes and one of West Point. Hone, Mayor of New York in 1825–26, was a man of wealth who was respected as a connoisseur of the arts.[83] Another patron was Thomas Dixon, a Manhattan merchant, who evidently commissioned from Megarey the two scenes of Niagara that were also

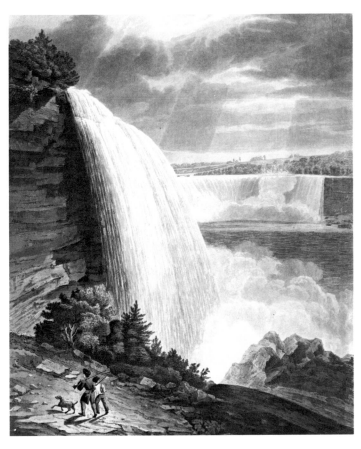

Fig. 12 John Hill. *Niagara Falls. Part of the American Fall, from the foot of the Stair Case*. 1829–30. Colored aquatint, after William James Bennett. Lenox Collection, Print Collection [checklist no. 13]

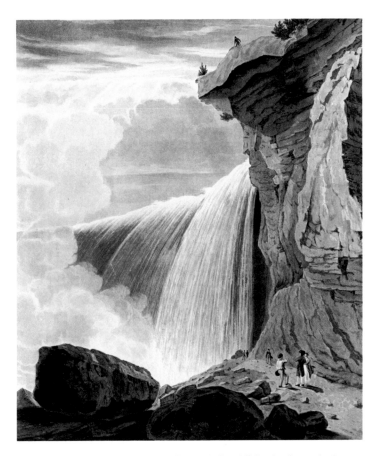

Fig. 13 John Hill. *Niagara Falls. Part of the British Fall, taken from under the Table Rock*. 1829–30. Colored aquatint, after William James Bennett. Lenox Collection, Print Collection [checklist no. 14]

shown. A dedication to Dixon appears on both the aquatints, and he is listed as owner (presumably of the original watercolors) in the exhibition record of 1832.

By this time, Bennett had embarked on the series of views of American cities which constitute the crowning point of his career as artist and as printmaker (see figs. 15, 16, 18–22, 32, 33, 36–38, frontispiece, and cover illustration). Nineteen views make up the series, all buoyant in rendering and executed in aquatint on folio-size plates.[84] They were never issued as a bound volume, a costly proposition that could possibly have led to financial failure; as it turned out, the prints probably enjoyed greater circulation as separates. Bennett designed some of the views; the majority were based on the designs of others. All of them were executed in aquatint by Bennett himself and in this sense form a signature album. The plates bear the imprint of various publishers, chiefly Henry Megarey and Lewis P. Clover.[85] Three of the artists who furnished the designs—George Cooke, John Gadsby Chapman, and Frederick Grain—were known to Bennett through the NAD. Two others—John Hill and his talented son, John William Hill—were personal friends.

The aquatints, rightfully considered the finest collection of folio views of American cities, provide abundant evocation of nineteenth-century America with particular emphasis on cities that owed their existence and prosperity to the presence of water. From his original designs for the profiles of Baltimore, Boston, Buffalo, New York, Washington, and West Point, we can see how Bennett was capable of orchestrating a varied topographical vocabulary: landscape, hills, buildings, water, bridges, ships, trees, bushes, figures, and intermittent genre scenes. Each of these elements is rendered with characteristic precision and clarity. In his view of *Baltimore from Federal Hill* (fig. 15), one of the

earliest (probably drawn in 1830), and indicative of what was to come, we enter the scene on open pastoral grounds with geese flocking, chickens feeding, youth idling, dogs wandering, and goats ruminating at the edge of a bluff where scattered foliage is delineated with richness and variety.[86] The tranquil foreground setting is imaginatively juxtaposed with Baltimore's dense, urban terrain. Separating the two is the Patapsco River where steamboats are beginning to dominate a riverscape once bedecked exclusively by tall masts and sails. The water, with its reflected light and mirroring surface, is used by Bennett to soften the features of nature and to lend grace to the granite impenetrability of the waterfront buildings. Such a topographical format largely adheres to the formal conventions of landscape painting worked out by Claude Lorrain in the seventeenth century: foreground in bucolic design, middle ground linked by a water course or road to the background and to the distant horizon. Bennett adapted the format to idealize his settings of American cities while retaining the kind of faithfulness to topographic fact that makes his views invaluable. He further intensified the idealization on the aquatint plate through the manipulation of tones to render the design awash in light. Bennett's Baltimore view, declared the *Baltimore American* of September 28, 1831, has been "pronounced by judges to be the best print of the kind ever published in the United States."[87]

If Baltimore could make that claim, other cities could, too: the artist maintained a level of excellence throughout the series. New York could certainly make that judgment with the view of *New York, from Brooklyn Heights* (see cover illustration), an example of Bennett's artistic collaboration in developing the series. Here, Bennett based his aquatint after the dramatic cityscape of John William Hill. For his portrait of urban splendor at full stretch, the young Hill (he was twenty-four years old at the time) presents five different topographic spheres: a scene

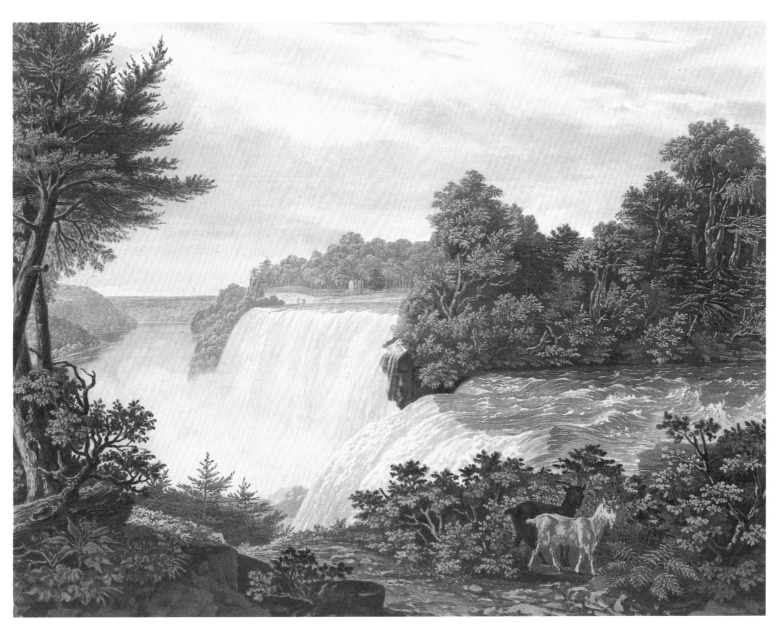

Fig. 14 *Niagara Falls… View of the American Fall, taken from Goat Island.* 1830.
Colored aquatint. Print Collection [checklist no. 15]

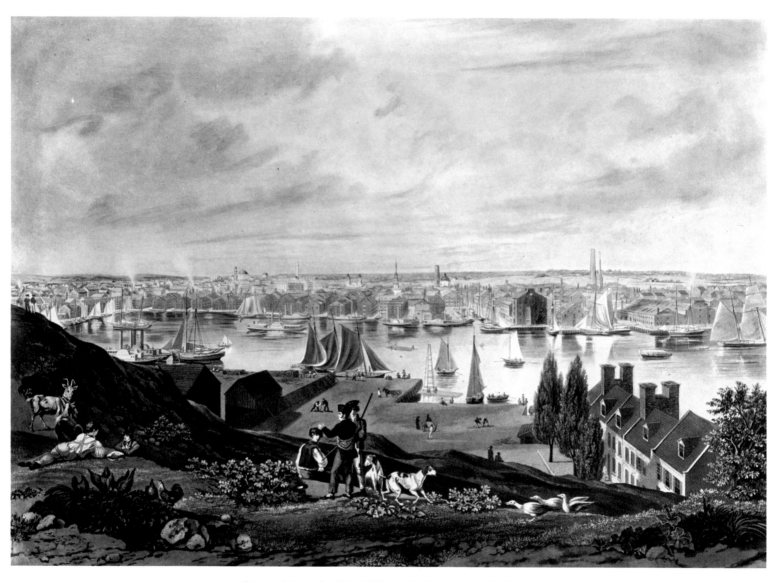

Fig. 15 *Baltimore from Federal Hill.* 1831. Colored aquatint. The Phelps
Stokes Collection, Print Collection [checklist no. 17]

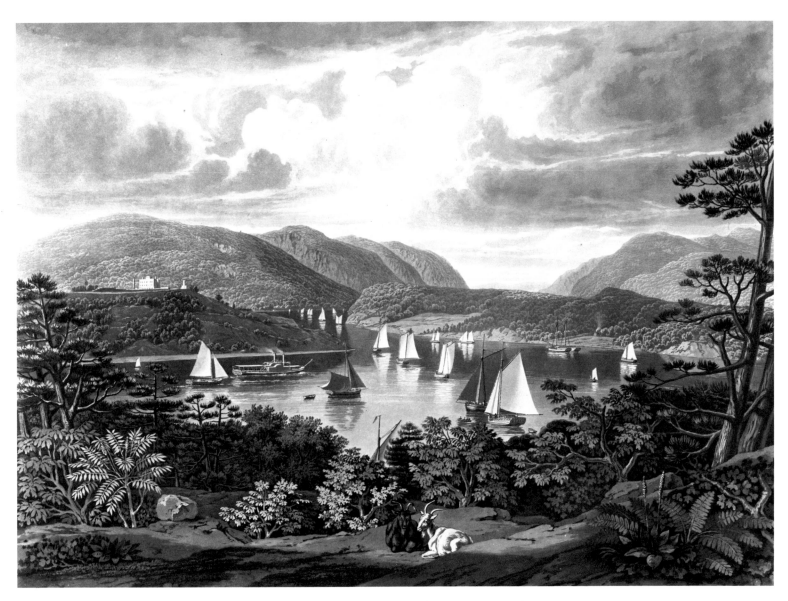

Fig. 16 *West Point, from Phillipstown.* 1831. Colored aquatint. The Phelps
Stokes Collection, Print Collection [checklist no. 19]

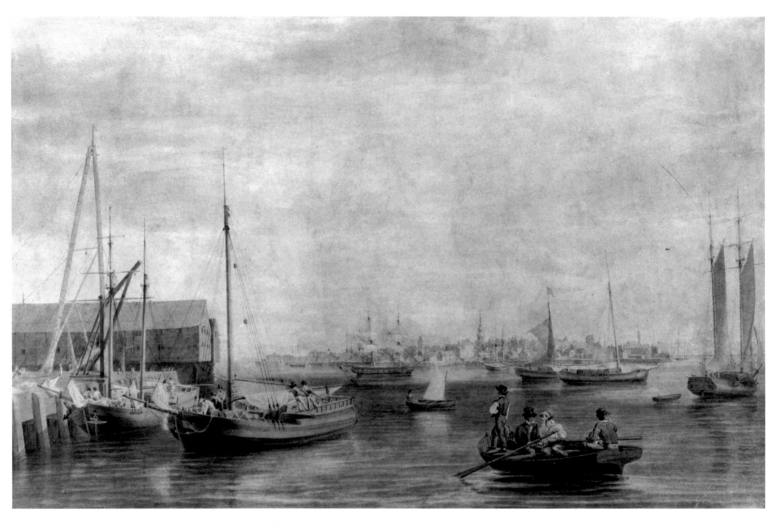

Fig. 17 [*Boston, From the Ship House, west end of the Navy Yard*]. Probably 1832.
Watercolor. The Phelps Stokes Collection, Print Collection
[checklist no. 20]

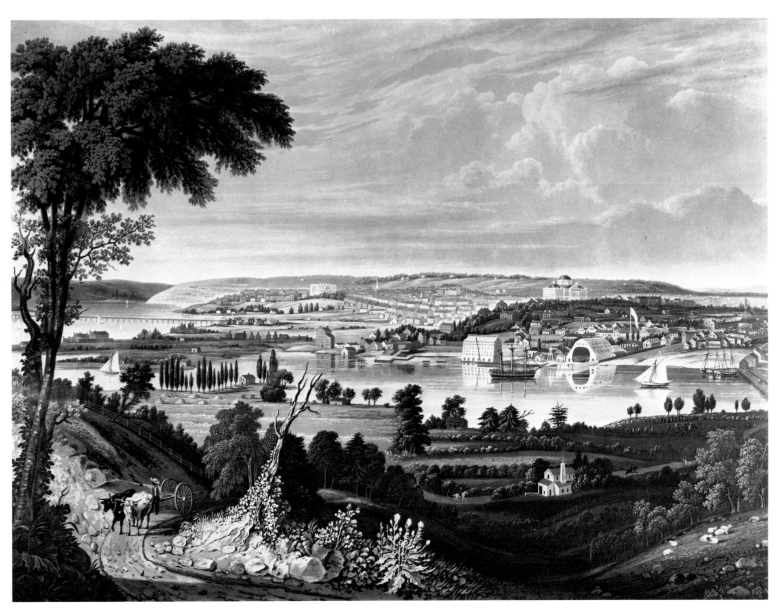

Fig. 18 *City of Washington From beyond the Navy Yard.* 1834. Colored aquatint,
after George Cooke. The Phelps Stokes Collection, Print Collection
[checklist no. 26]

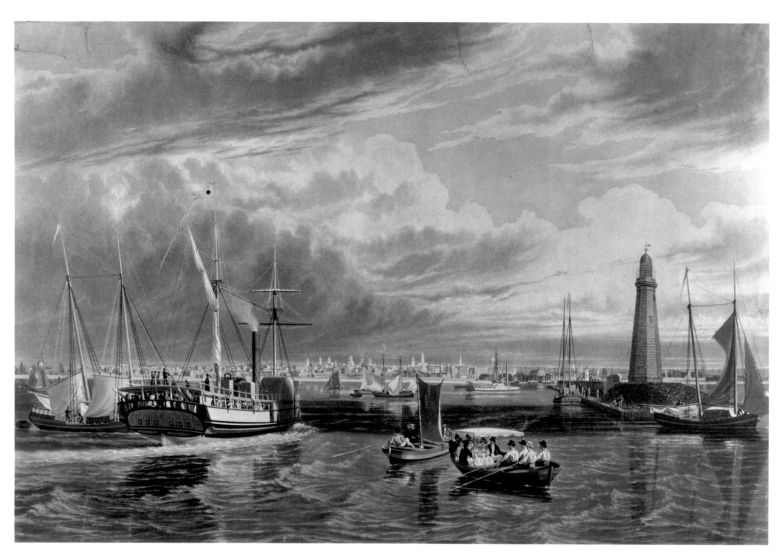

Fig. 19 *Buffalo, from Lake Erie.* 1836. Colored aquatint, after John William
Hill. The Phelps Stokes Collection, Print Collection [checklist no. 30]

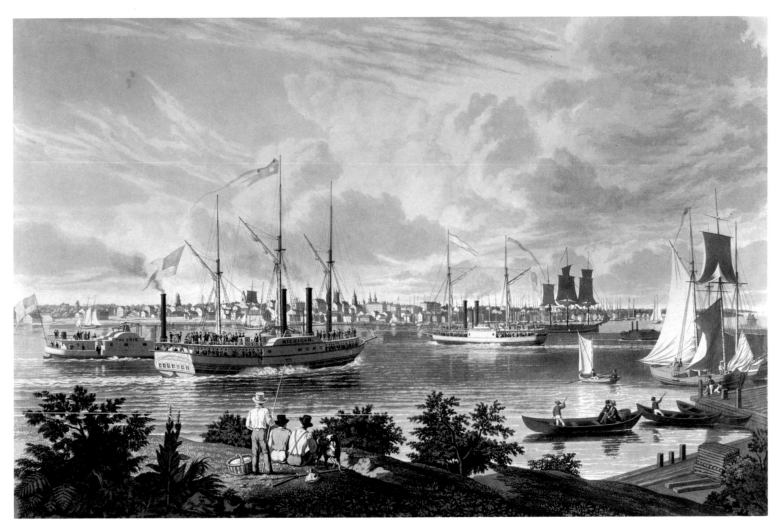

Fig. 20 *City of Detroit, Michigan.* 1837. Colored aquatint, after Frederick
Grain. The Phelps Stokes Collection, Print Collection [checklist no. 33]

Fig. 21 [*Mobile. Taken from the Marsh opposite the City near Pinto's residence*].
1842. Aquatint, after William Todd. Emmet Collection, Print Collection
[checklist no. 41]

Fig. 22 *A Brisk Gale, Bay of New York*. 1839. Colored aquatint. The Phelps
Stokes Collection, Print Collection [checklist no. 37]

in Brooklyn, nautical activity on the East River, the dense settlement of Manhattan, the Hudson River, and the far-off shores of New Jersey, all the while maintaining indisputed harmony in the wide pictorial world he has constructed. He had done this innovatively, without dependence on the traditional devices of a foreground landscape, coulisse trees, or other accessory elements often used in achieving a compact design for a distant view. With characteristic craftsmanship in working up the aquatint plate, Bennett, in turn, has further bonded the compositional elements through his remarkable handling of the element of light to define space. In laying down the porous ground for working the plate, he has varied the grain of his resin, and used judiciously bold strokes of stop-out varnish to achieve the luminous light demarcating the two rivers. Land, sky, and water are all wrapped in a radiance that enhances the creativity of Hill's rendering and allows us to look at the city with fresh wonder and delight.[88]

Bennett was subsequently involved in two other picture series of quite another nature. In both of them, his role was exclusively as engraver. For the earlier of the two, he was teamed with George Harvey, a watercolorist of considerable stature born and trained in England who settled in Hastings-on-the-Hudson, New York, around 1833. A friend and neighbor of Washington Irving, he designed Irving's nearby "Sunnyside" residence.[89] During the long period he spent building his own house, Harvey became intrigued with effects of shifting light on the topographic scene during the course of the day as well as during the progression of the seasons. He made many watercolors to illustrate these fleeting changes, and while on a trip to London and Paris, he was encouraged, in the artists' circles that he frequented, to submit them for publication. On his return, Harvey planned to issue a total of forty atmospheric studies, but unfortunately, the project proved too costly

and only one group of seasonal landscapes (four plus a title page) was eventually published (see figs. 23–27). All of the watercolors, however, were available for viewing by the public in Harvey's studio. The landscapes were masterfully rendered in aquatint by Bennett, and the assembled portfolio, with hand-colored plates, was issued simultaneously in London and New York in 1841 under the title *Harvey's Scenes of the Primitive Forest of America.*[90] For the letterpress text that accompanied each of Bennett's engravings, Harvey had the literary help of Washington Irving. In addition, he was permitted to carry the endorsement of three leading painters—Washington Allston, Samuel F. B. Morse, and Thomas Sully—who praised Harvey particularly for having been, as Allston put it, "not only successful in giving the character of our Scenery, but remarkably happy in clothing it with an American Atmosphere...."[91] This last point was most important to emphasize at a time when art was basking in its discovery of America as a font of new beauty. Further, the style of Harvey's watercolors was breaking new ground. "[They] are remarkable in their freedom from the didactic, grand manner found in Cole's landscape paintings of the same time," writes Theodore E. Stebbins. "Indeed, they look ahead to the late 1850s, when tight stippling and an evocation of light and atmosphere became popular in American art."[92] Though the project was a financial failure, Bennett's work had once again placed him at the forefront of new vistas in art.

Before his collaboration with Harvey ended, Bennett suffered a major blow. On January 6, 1840, he was dismissed as Keeper of the National Academy of Design. There seems to have been little fanfare about it, the Council minutes reading simply that "on motion of Mr. [Samuel F. B.] Morse [president] it was resolved that the council proceed to the selection of a keeper ... the present keeper being so by courtesy only."[93] Two letters in the archives of the Academy, written by the artist,

Fig. 23 *No. 1 Harvey's American Scenery* (title page). 1841. Colored aquatint, after George Harvey. From *Harvey's Scenes of the Primitive Forest of America*. The Phelps Stokes Collection, Print Collection [checklist no. 38]

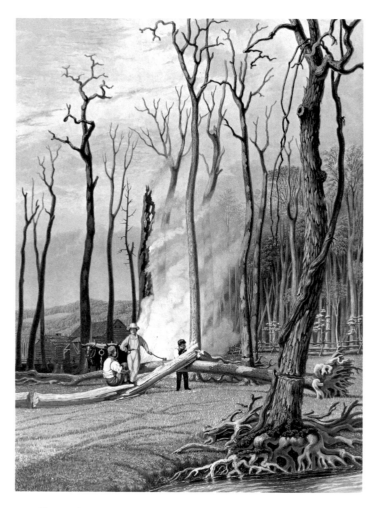

Fig. 24 *Spring No. 2 Burning Fallen Trees in a Girdled Clearing*. 1841. Colored
aquatint, after George Harvey. From *Harvey's Scenes of the Primitive Forest of
America*. The Phelps Stokes Collection, Print Collection [checklist no. 38]

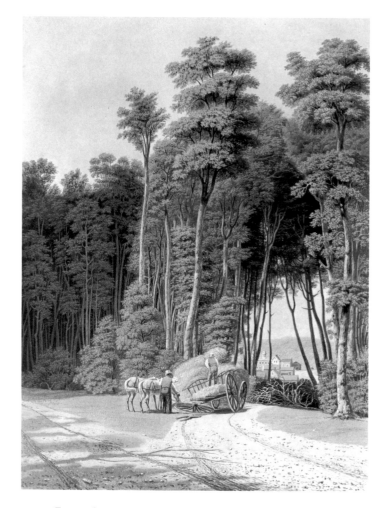

Fig. 25 *Summer No. 3 A Road Accident*. 1841. Colored aquatint, after
George Harvey. From *Harvey's Scenes of the Primitive Forest of America*.
The Phelps Stokes Collection, Print Collection [checklist no. 38]

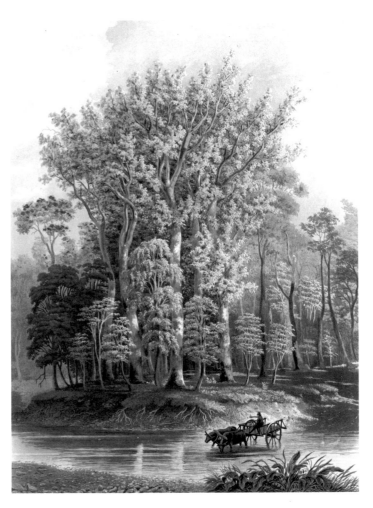

Fig. 26 *Autumn No. 4 Gigantic Sycamores*. 1841. Colored aquatint, after
George Harvey. From *Harvey's Scenes of the Primitive Forest of America*.
The Phelps Stokes Collection, Print Collection [checklist no. 38]

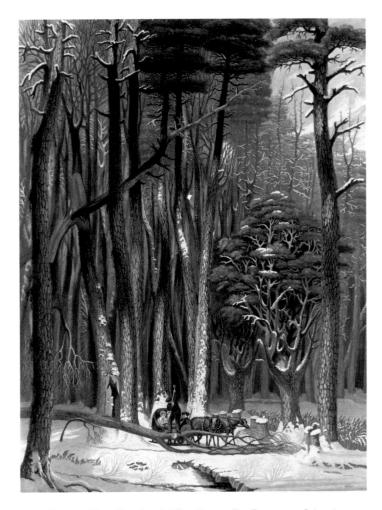

Fig. 27 *Winter No. 5 Impeded Travellers in a Pine Forest*. 1841. Colored
aquatint, after George Harvey. From *Harvey's Scenes of the Primitive Forest of
America*. The Phelps Stokes Collection, Print Collection [checklist no. 38]

reveal his utter chagrin at the loss of his custodianship, particularly since it meant the accompanying loss of what the Council termed the "commodious and valuable accommodations afforded for your private business." By the end of the month, the matter was closed. Bennett received compensation in the amount of $250 "for extra services" and was permitted to retain his apartment for a month.[94] He continued to attend NAD annual meetings through 1843 and he agreed to be a member of the 1842 Committee on Arrangements. Oddly, considering the many years of his association with Academy affairs, the Council's record book reveals little of Bennett's personality. His habits and beliefs, viewed through the eyes of his colleagues, remain in shadow.[95]

Whether Bennett owned, or preferred to rent, the extensive printmaking equipment (including a press) required for his intaglio work is not known. Perhaps he depended largely on the Academy's facilities during his tenure there as well as on outside printers. If he owned the equipment, presumably it was transferred to 285 Broadway, his new address after leaving Clinton Hall.[96] It was from there, in the early 1840s, that he undertook to make aquatint plates for F. B. Tower's *Illustrations of the Croton Aqueduct*, an impressive volume dedicated "to the inhabitants of the city of New York, whose enterprise is strikingly exemplified by the construction of the Croton Aqueduct." The book stands as an eloquent document of an extensive engineering project that brought running water to the residents of Manhattan.[97] Using the resources of the Croton River, engineering was begun in 1837 and finalized in 1842 with a tumultuous celebration. For Bennett, as for the more than 350,000 inhabitants of New York, it was a momentous event. "Water! Water! is the universal note which is sounded through every part of the city, and infuses joy and exultation into the masses," records Philip Hone spiritedly in his diary entry for October 12 of that year.[98] The

distributing reservoir that held the water brought into the city by the Croton aqueduct was an Egyptian mastaba-like structure, erected on the site (Fifth Avenue and 42nd Street) where The New York Public Library now stands. A drawing of this massive edifice is contained in one of the twenty-four plates that embellish the volume prepared by Tower, an engineer associated with all phases of the Croton project. For his account, he relied chiefly on the printed documents of the city's Common Council, prefacing his work with a brief history of the celebrated aqueducts of Europe and South America.

Seven of the Tower drawings executed in aquatint by Bennett show the latter's talent for giving sparkle to prints with a focus on engineering as well as on the picturesque. Pervading Tower's sober presentation of a *View above the Croton Dam* (fig. 28) is a radiance imparted by the velvety textures which Bennett gives to the woodland foliage and by the limpid, glass-like quality defining the water. His clouds, too, are distinctive: they rest on the bosom of the air. The small number of plates executed by John William Hill manifest, by comparison, a less fluent handling of the aquatint ground, resulting in fewer subtleties in the transitions between light and dark. Small, awkward patches of black appear here and there as interruptions rather than gradations in the tonal texturing. Perhaps one of the most splendid of Bennett's plates is the *Croton Aqueduct at Yonkers* where rich chiaroscuro effects register a tonal sensitivity that binds the pictorial elements and adds depth to the basic Tower design. An indication of the artist's delight in working on these plates is the watercolor he executed long after the Tower book was published, entitled *View of High Bridge and the Harlem River* (fig. 39).[99] Bennett conceived it in the spring of 1844, the year of his death. The High Bridge, or aqueduct extending over the Harlem River, had not been completed when Tower went to press. As topo-

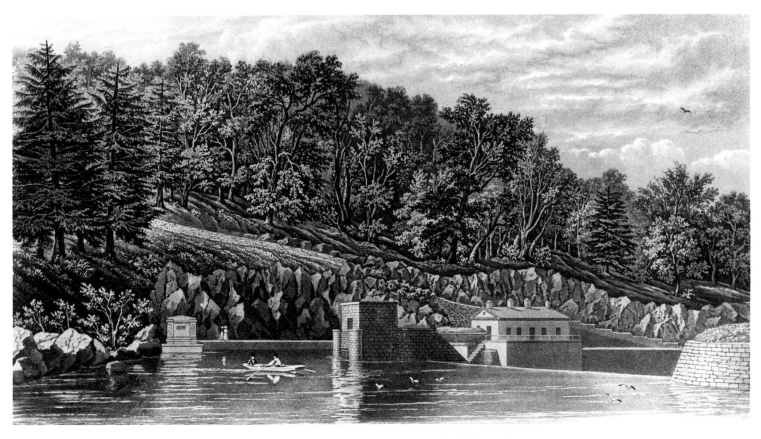

Fig. 28 *View above the Croton Dam.* 1843. Aquatint, after F. B. Tower. From
Illustrations of the Croton Aqueduct. Science and Technology Research Center
[checklist no. 42]

Fig. 29 *The Archipelago in a Levanter.* 1843. Aquatint. From *The New Mirror.*
Print Collection [checklist no. 44]

Fig. 30 *Catskill Mountains.* 1843. Aquatint. From *The New Mirror.*
Print Collection [checklist no. 46]

graphical portraiture, the watercolor differs from Bennett's usual designs in its simplicity of conception. The High Bridge, with its row of classical Roman arches, is the only granite feature in the tranquil landscape setting; Bennett has rendered it less as an interruption in the rhythm of nature than as a harmonious part of it. The watercolor is signed and dated in his hand.

During the time he worked on the Tower plates, Bennett continued to contribute a fair number of views to the *New-York Mirror*, an eight-page cultural weekly that was untiring in its promotion of the arts.[100] Launched in 1823, the *Mirror* published literary reviews, original tales and verses, reports on the theatrical scene, notes on music, and comments on the foibles of the age. It often carried engravings, and frequently discoursed on engraving as a topic worthy of special focus. From July 1843 to August 1844, ten of Bennett's views appeared as aquatints (see figs. 29, 30). It was of particular significance for Bennett's career that this influential weekly was a staunch champion of his art. Accolades invariably appeared following an exhibit of the artist's watercolors but, even beyond that, the *Mirror* was happy to go on record in his personal defense. Soon after Bennett was dismissed from the National Academy of Design, the paper devoted space to the incident, discreetly introducing the subject by reporting on a beautiful gold snuffbox presented to the departing Bennett by the Academy's students. "The students deserve praise," declared the *Mirror*, "for remembering in such appropriate style an artist who has, on all occasions, taken so much pains to communicate the knowledge he possesses to the young gentlemen under his instruction." It is a matter of regret, pronounced the paper, "that the academy is about to lose so efficient an officer."[101]

Bennett's work also had exposure at the three exhibits of the Apollo Association and, later, one at the American Art-Union (the Apollo Association's new name). At this latter 1844 show, Bennett was represented by six landscapes, two of them apparently never previously shown. The American Art-Union had purchased all six works, distributing them, as was the Art-Union's custom, in the form of prizes to recipients whose names are documented in the exhibition record.[102] This was the last exhibit in which Bennett was represented. He died in New York on May 13, 1844.

Sometime earlier, when there had appeared to be a slack in the artist's output of watercolors, the *New Mirror* took the occasion to ask: "What has become of Mr. Bennett? We miss from the exhibitions his beautiful and silvery landscapes in water colours, and the blank is not easily filled."[103] But the blank *is* being filled. Through an increasing appreciation of the work of this artist, attended by scholarly investigation of American topographic art of the nineteenth century, a balanced portrait is beginning to emerge. We find that early on, Bennett set himself a double course in aesthetic exploration—that of a watercolorist with a specialty in landscape, and that of a printmaker who did not permit the documentary, reproductive, or commercial demands of his craft to diminish the artistic considerations. In both roles, he was at the forefront of dynamic changes in art, first in England, then in America. While he himself never set the tenor of change, his performance was spurred by the heightened ambiance in which those changes took place: his allegiance to excellence was a contributing factor in the larger flow of events.[104] As one of the bearers of the English reverence for the romance of landscape, this London-trained artist preferred no departure from the traditional pictorial values that fostered a pairing of idealism with realism; he retained lines of communication with the immediate past, strengthening and deepening the representational forms in which he was schooled. A realism heightened through the poetics of light

marks Bennett's watercolors and topographic plates, and this characteristic holds even when he based his prints on the sometimes inferior designs of others. In viewing his elegant aquatints, the eye is always more than just satisfied.

Notes

1 James W. Lane, "New Exhibitions of the Week," *The Art News*, January 27, 1940, p. 38. The exhibition under review (signed "J.W.L.") was staged by Harlow and Company.

2 *The Repository of Arts, Literature, Commerce, Manufactures, Fashions and Politics*, VII (June 1812), 337. The critique of a watercolor painted by William James Bennett (hereinafter referred to in the notes as WJB) is contained in a review of an exhibition staged by the Associated Painters [Artists] in Water-Colours.

3 William H. Pyne, editor of the short-lived *Somerset House Gazette and Literary Museum* (1823–24) closely followed the "rise and progress of water-colour painting" in England at this time through the pages of his *Gazette*.

4 A compilation by John Roland Abbey gives a good idea of the range and quality of the illustrated volumes published during this era. See his *Life in England in Aquatint and Lithography, 1770–1860* (London: Curwen Press, 1953). The expense of these volumes landed at least one publisher in serious debt. A letter from William H. Pyne describing his predicament, written from King's Bench prison, is quoted in John Lewis Roget, *A History of the "Old Water-Colour" Society* (London: Longmans, Green & Co., 1891), vol. 1, p. 239. The undertaking that got Pyne into trouble was his elaborate publication in three royal quarto volumes: *The History of the Royal Residences of Windsor Castle . . .*, published in 1819.

5 One of the more comprehensive texts on the process and history of aquatint engraving is S. T. Prideaux's *Aquatint Engraving* (London: Duckworth & Co., 1909).

6 Presumably WJB registered at the Royal Academy in 1799, but this is conjecture; no monograph or article on this artist has as yet been published. Some of the essential facts pertaining to WJB's life and the development of his career are not known with certainty because of the absence of primary documents (diaries, letters, statements, contracts, bills, and personal reminiscences of friends). The one solid date we have for his biography is the date May 13, 1844, given on his death certificate, which states that he was then sixty years old. The year 1844, therefore, forms the basis on which other dates are reckoned. A brief biographic account (one and a half pages) is given in William Dunlap, *A History of the Rise and Progress of the Arts of Design in the United States* (Boston: C. E. Goodspeed and Co., 1918), vol. 3, pp. 45–47.

7 Most of the details on student requirements and curriculum are gleaned from William Sandby, *The History of the Royal Academy of Arts*, 2 vols. (London: Longman, Green, Longman, Roberts, & Green, 1862).

8 The frequently cited remark was made by James Northcote, English artist, writer, and critic. It is recorded in "Anecdotes of Northcote," *Library of the Fine Arts; or Repertory of Painting, Sculpture, Architecture, and Engraving* (London: M. Arnold, 1831), vol. 2 (no. 10), pp. 234–235.

9 Dunlap, *History*, vol. 3, p. 45. It is also from Dunlap that we learn of WJB's attendance at the Royal Academy "at a suitable age" (p. 45).

10 The address is cited in Algernon Graves, *The Royal Academy of Arts: A Complete Dictionary of Contributors and Their Work from Its Foundation in 1769 to 1904* (New York: B. Franklin, 1972), vol. 1, p. 181, and vol. 8, p. 231. Biographical sketches of the Westall brothers are contained in [Michael] Bryan, *Bryan's Dictionary of Painters and Engravers* (London: George Bell and Sons, 1905), vol. 5, pp. 357–358.

11 Rudolph Ackermann, *The Microcosm of London* (London: T. Bensley, 1808), vol. 1, opp. p. 9. The plate, which is hand-colored, was engraved in aquatint by J. Bluck.

12 The titles of the works by West, Turner, Lawrence, Fuseli, and Copley are given in Graves, *The Royal Academy of Arts*, under the Royal Academy's exhibition records for each of these artists.

13 William T. Whitley, *Art in England, 1800–1820* (Cambridge: University Press, 1928), p. 88.

14 Joseph Farington, *The Diary of Joseph Farington* (New Haven: Yale University Press, 1979), vol. 4, p. 1539 (diary entry for April 18, 1801). Farington's journal is a rich font of information on the English cultural scene during the Romantic Age. He is a diarist who writes well, was always at the center of things, and was quick to pick up meaningful tidbits.

15 The aquatints are listed as nos. 129, 135, 150, and 151 in Mantle Fielding, *American Engravers upon Copper and Steel* (Philadelphia, 1917). The same Carr drawings were executed in aquatint in a slightly larger size by Thomas Medland and published as part of a series of twelve aquatints (all executed by Medland) in John Carr, *The Stranger in France: or, A Tour from Devonshire to Paris* (London: J. Johnson, 1803). It may be that WJB's stint with the British Army prevented his commitment to the entire series, and that a larger format was subsequently deemed more suitable for the book when Medland undertook the project. It is also possible that the Bennett aquatints were issued as separates following publication.

16 William H. Pyne pays tribute to Richard Westall's prowess as an engraver in an article entitled "Painters Engravers, and Engravers Painters," which appeared in the *Somerset House Gazette*, XXIII (March 13, 1824), 354.

17 For an indication of the extent to which English topography was documented before 1818, see William Upcott's *A Bibliographical Account of the Principal Works Relating to English Topography*, 3 vols. (London: Richard and Arthur Taylor, 1818).

18 Prideaux, *Aquatint Engraving*, pp. 108–109, lists the principal aquatint plates executed by Sandby.

19 Dunlap, *History*, vol. 3, p. 46.

20 Bryan, *Bryan's Dictionary*, vol. 5, pp. 357–358, recounts that the younger Westall survived a shipwreck off the coast of Australia and, after being rescued by a ship bound for China, spent several months there "visiting the interior and making sketches, which have now much interest."

21 A brief history of this association is provided in Roget, *History*, vol. 1, pp. 228–231.

22 Gartside's books are *An Essay on Light and Shade, on Colours, and on Composition in General* (London: Printed for the Author by T. Davison, 1805), and *Ornamental Groups, Descriptive of Flowers, Birds, Shells, Fruit, Insects, &c. and Illustrative of a New Theory of Colouring, from Designs and Paintings by M. Gartside* (London: William Miller, 1808). The latter book is the earliest in which WJB's name appears as a professional printmaker. There are three signed plates. The two books are listed in Abbey, *Life in England*, entries 127 and 128.

23 It is from biographical accounts of Frederick Nash, a distinguished artist whose work drew praise from Benjamin West, that we learn of the existence of WJB's sister Eliza (Roget, *History*, vol. 1, p. 490). She apparently kept a journal, which, as of this date, has not been located. Richard Westall drew her portrait (whereabouts unknown) and exhibited it at the Royal Academy in 1804.

24 A thorough account of the events leading to the formation of this group and its subsequent evolution forms the main thesis of Roget's *History*.

25 *The Microcosm of London*, vol. 2, p. 31.

26 Ibid., vol. 2, opp. p. 25. Augustus Pugin was at this time a member of the watercolorists' band.

27 Roget, *History*, vol. 1, p. 231.

28 *The Microcosm of London*, vol. 2, p. 36.

29 T. S. R. Boase, *The Oxford History of English Art, 1800–1870* (Oxford: Clarendon Press, 1959), p. 41. This was not, however, without complications, because until 1863 membership in the Royal Academy automatically excluded membership in other societies.

30 *The Repository of Arts*, III (June 1810), 434.

31 Ibid., p. 432.

32 Ibid., VII (June 1812), 337.

33 *The Microcosm of London*, vol. 1, opp. p. 10.

34 Sandby, *History*, vol. 2, p. 446. The gold medal in sculpture had similar requirements. It was to be given for the best historical bas-relief, or alto-relief, consisting of two or more figures, or for a group in the round. The principal figure was to be not less than three feet high.

35 Ibid., vol. 2, p. 413. The paintings that capped the prize soon after WJB arrived as a student were entitled *Clytemnestra Exulting over Agamemnon* (1801) and *Achilles* (1803).

36 British Museum, Department of Greek and Roman Antiquities, *A Description of the Collection of Ancient Marbles in the British Museum*, Part IV (1819), plates XXVI and XXVII. The sizes of these plates are 7.13 x 9.14 inches; 196 x 250 mm.

37 William Combe, *A History of The University of Oxford* (London: R. Ackermann, 1814), vol. 2. The plates appear opposite pages 72 and 149.

38 Ibid., vol. 1, p. viii.

39 Ibid.

40 Pyne, *The History of the Royal Residences*, 3 vols. (London: A. Dry, 1819). The majority of WJB's plates are in volume 1, with the remainder divided almost equally between volumes 2 and 3. The earliest plate is dated February 1, 1816; the latest, September 1, 1819.

41 James Ralfe, *The Naval Chronology of Great Britain* (London: Whitmore and Fenn, 1820), vol. 3, opp. p. 124.

42 Roget, *History*, vol. 1, pp. 269–271, where there is a discussion of some of the more remarkable paintings that were hung in the final exhibit. A summary account of the existence of the Associated Artists in Water-Colours is also given in Charles Holme, ed., *The "Old" Water-Colour Society, 1804–1904* (London: The Studio, 1905), pp. H xiv and H xv.

43 Roget, *History*, vol. 1, pp. 417 and 557, where the exhibition records of the Society are printed without an indication of the titles of works submitted. WJB is listed as Bennett, W. T. (p. 417) and as Bennet, W. J. (p. 557).

44 Ibid., vol. 1, p. 400.

45 Algernon Graves, *Dictionary of Artists Who Have Exhibited Works in the Principal London Exhibitions from 1760 to 1893* (New York: Burt Franklin, 1970), p. 23. WJB's record appears here under entries in two different names: J. Bennett and William James Bennett.

46 Roget, *History*, vol. 1, p. 514. The author says that the seven watercolors presented by WJB are "views near Naples, and two from the Straits of Gibraltar. In 1822 he sent no drawing; but made excuses, which were accepted."

47 Ibid. In this brief paragraph, Roget also hints that WJB was in financial trouble, but he gives no clear explanation; he alludes in a baffling way to the disastrous "failures" of the English banker, Henry Fauntleroy, who was executed for forgery in 1824. Roget quotes from a manuscript source in the British Museum to the effect that WJB "was obliged to leave this country for America, and became President of the New York Academy."

48 Mary Gartside, *Ornamental Groups*, p. 2.

49 *The New-York Mirror, A Weekly Journal, Devoted to Literature and the Fine Arts*, 10 (July 14, 1832), 11.

50 Cited in Gloria Gilda Deák, *Picturing America, 1497–1899* (Princeton: Princeton University Press, 1988), vol. 1, entry 228, where a description of the Philadelphia album appears. Descriptions of the three other albums are also contained in that volume: *Itinéraire pittoresque du fleuve Hudson*, entry 299; *Picturesque Views of American Scenery*, entry 315; and *The Hudson River Portfolio*, entry 320. Reproductions of all the views are contained in vol. 2.

51 The series by Jacques Le Moyne de Morgues is described in Deák, *Picturing America*, entry 9, and in Paul Hulton, *The Work of Jacques Le Moyne de Morgues, a Huguenot Artist in France, Florida and England*, 2 vols. (London: Published for the Trustees of the British Museum by British Museum Publications Limited in association with the Huguenot Society of London, 1977). John White's drawings are documented in Helen Wallis, *Raleigh & Roanoke: The First English Colony in America, 1584–1590* (Raleigh: America's Four Hundredth Anniversary Committee, North Carolina Department of Cultural Resources, 1985). *The Atlantic Neptune* is described in Deák, entry 130.

52 J. R. Abbey, *Travel in Aquatint and Lithography, 1770–1860*, 2 vols. (Lon-

don: Curwen Press, 1956–57), lists the topographic albums published in England beginning in 1770. For a recent discussion of England's role in the elevation of landscape art, see Scott Wilcox, *British Watercolors* (New York: Hudson Hills Press, in Association with the Yale Center for British Art and the American Federation of Arts, 1985). Wilcox writes that "landscape was that branch of the pictorial arts to which British painters made their most significant contribution in the international arena" (p. 9).

53 Joshua Shaw, *Picturesque Views of American Scenery* (Philadelphia, 1819–21), introduction. The New York Public Library owns a copy of the Shaw portfolio.

54 *Library of the Fine Arts; or Repertory of Painting, Sculpture, Architecture, and Engraving* (London: M. Arnold, 1831), vol. 1 (no. 6), p. 509.

55 [*The Hudson River Portfolio. A Series of Views Drawn by William G. Wall and Engraved by John Hill*. Published by Henry J. Megarey in New York, 1821–25], prospectus inside cover. An issue of the *Portfolio* is owned by The New York Public Library. Megarey's name appears on the prints as Henry I. Megarey.

56 Richard J. Koke develops this theme in his study entitled "John Hill, Master of Aquatint, 1770–1850," *The New-York Historical Society Quarterly*, 43 (January 1959), 51–118. Koke holds that the "initiative in American landscape art lay largely in the hands of artists and engravers of English or Irish birth" (p. 77).

57 Ibid., pp. 69, 109. Koke pegs the Golden Age of aquatint art in America to the 1820s and 1830s. By the next decade, this printmaking technique was overtaken by the cheaper processes of steel engraving and lithography, both of which allowed for a greater number of impressions—from the steel and from the stone—than was possible with the soft copper required for aquatint.

58 Richard J. Koke provides a biographical account of John Hill (cited above, note 56) and an annotated checklist of his works: *A Checklist of the American Engravings of John Hill (1770–1850), Master of Aquatint* (New York: The New-York Historical Society, 1961).

59 The precise year of Bennett's arrival in America is not documented, but 1826 seems accurate. William Dunlap gives the year as 1816 in his *History*, vol. 3, p. 45, but this is undoubtedly a typographical error, as WJB was active in England through 1825. Although Dunlap is one of the few biographical sources we have for WJB (they were colleagues at the NAD), his *History* contains errors. The author was quite ill when he undertook the publication of his three-volume work (he was also in financial straits) and probably Dunlap could not muster for this ambitious oeuvre the meticulous attention it deserved. *Megarey's Street Views in the City of New-York* are described in Deák, *Picturing America*, entry 350, and in I. N. Phelps Stokes, *The Iconography of Manhattan Island, 1498–1909* (New York: Robert H. Dodd, 1918), vol. 3, pp. 589–590.

60 The ceremonies opening the Erie Canal took place on October 26, 1825. They were recorded in a series of lithographs and engravings bound into a published report entitled *Memoir*, which was presented to the Mayor of New York. The *Memoir* is described in Deák, *Picturing America*, entry 339, which carries an illustration of the title page.

61 *The Repository of Arts*, VII (January 1812), opp. p. 44.

62 They are described and illustrated in Deák, *Picturing America*, entries 360 and 362.

63 *The Microcosm of London*, vol. 3, pp. 217–218.

64 *Billingsgate Market* appears in *The Microcosm of London*, vol. 1, opp. p. 63.

65 Megarey's published announcement is contained in Stokes, *Iconography*, vol. 3, p. 589. The three prints of the first number were issued in blue paper covers at a cost of five dollars per number. Megarey stated on the cover that "the series will be complete in Four Numbers; each Number to contain Three correct Views of the principal Streets in the City. . . . The Drawings will be made, and the Pictures engraved in Aquatint, in the very best style, by William J. Bennett."

66 WJB was receiving commissions from Megarey at least as late as 1842, two years before the artist's death. In that year, Megarey took out a copyright on WJB's aquatint of Mobile, Alabama (described and illustrated in Deák, *Picturing America*, entry 515).

67 The NAD had a large voice in shaping the American artistic scene for most of the nineteenth century; by the early decades of the current century, however, its role had become largely historic. The dynamic changes in art wrought through the Modernist movement, which gave New York an international role, took place outside the NAD's sphere of influence.

68 The NAD was particularly proud that it was the first institution in the city established under the exclusive control of professional artists "in whom alone it was contended could Art, and its general dissemination, be properly placed" (Thomas S. Cummings, *Historic Annals of the National Academy of Design* [Philadelphia: George W. Childs, 1865], p. 5). A more recent study of the NAD is Eliot Candee Clark, *History of the National Academy of Design* (New York: Columbia University Press, 1954).

69 Cummings, *Historic Annals*, p. 35. "To call themselves *National Academicians*," huffed the *North American Review*, "is making a claim of distinction which, we must say, is out of proportion to their merits"; cited in Cummings, p. 45.

70 Ibid., p. 78. The exhibition was kept open in the evening, which had the effect of often doubling and even trebling the receipts for the day, comments Cummings. This second annual exhibition was held "in the room over Tylee's Baths in Chamber St." (Cummings, p. 110).

71 *National Academy of Design Exhibition Record, 1826–1860* (New York: Printed for The New-York Historical Society, 1943), vol. 1, p. 30. WJB also occasionally painted in oil, as we learn from the *New-York Mirror* (much later) in a favorable critique of a painting submitted in 1833. WJB "proves that the more permanent materials . . . are likewise at his command," *The New-York Mirror*, 10, no. 50 (June 15, 1833), 398.

72 *National Academy of Design Exhibition Record*, vol. 1, pp. 30–31.

73 "Resolved, that Mr Bennett be and he is hereby appointed Keeper of the National Academy of Design at the _____ salary per annum—that he

take charge of the property belonging to the Academy, of the School for the Study of the Antique, and that room in the new Building over the Library be appropriated to his use." *Minutes* of the Council of the National Academy of Design, March 22, 1830. The bound volume containing the manuscript minutes of the NAD Council meetings is held in the archives of the Academy.

74 Sandby, *History*, vol. 1, pp. 51–52.

75 A picture of Clinton Hall, a substantial four-story building, appears as part of *The Bourne Views of New York* illustrated in Deák, *Picturing America*, vol. 2, fig. 392. The *Bourne Views* were issued in 1831. By 1833, the NAD was looking for larger quarters.

76 *The New-York Mirror*, 8, no. 45 (May 14, 1831), 358. A general comment at the end of this review of the NAD's 1831 exhibition offers a further judgment: "... a more careful examination convinces us that the present is altogether superior to any previous exhibition of the institution. It is indeed extremely creditable to the contributing artists, and richly merits the encouragement with which, we perceive, the fashionable world is already beginning to reward their labors."

77 Ibid., 8, no. 27 (January 8, 1831), 214. WJB's designs appear in the first and last plates of William Cullen Bryant's *The American Landscape, No. 1* (New York: Elam Bliss, 1830). A two-page "prospectus," with Asher B. Durand and Elias Wade, Jr., given as the authors, follows the title page.

78 Ibid., 10, no. 42 (April 20, 1833), opp. p. 329, and 10, no. 47 (May 25, 1833), opp. p. 369. It was in the description attending the latter plate (*The Falls of the Sawkill*) that the *Mirror* reported on the demise of the *American Landscape* project: "it ... never passed beyond its first number."

79 Ibid., 9, no. 11 (September 17, 1831), 86. The *Mirror* talks of the cost of the prints as being "a comparatively trifling sum," without giving a figure.

80 Elizabeth McKinsey, *Niagara Falls* (Cambridge: Cambridge University Press, 1985), p. 144. Professor McKinsey also feels that Bennett's view (which she illustrates in fig. 58) is "perhaps the most controlled view" among the popular prints of Niagara that circulated in the 1830s and 1840s.

81 Described and illustrated in Deák, *Picturing America*, entries 363, 364, 367, and 368.

82 Ibid., entries 365 and 366.

83 *The New-York Mirror*, 9, no. 48 (June 2, 1832), 382. Philip Hone's art collection was quite impressive; his admiration for the leading artists of his day, and his support of the National Academy of Design, can be discerned in the entries of the voluminous diary he kept. Highlights from his art collection are listed in Allan Nevins, ed., *The Diary of Philip Hone, 1828–1851* (New York: Dodd, Mead & Co., 1927), vol. 1, p. xviii.

84 The nineteen views are documented in Deák, *Picturing America*, and in Stokes, *Iconography*, vol. 3, pp. 619–622. Koke, *A Checklist of the American Engravings of John Hill (1770–1850)*, pp. 61, 80, 81, recounts Hill's part in coloring impressions of two of the plates in this series.

85 The majority of the views were published by Clover, an art and print dealer, who owned a looking-glass and picture-frame shop with John Parker. The shop is illustrated in T. B. Thorpe, "New-York Artists Fifty Years Ago," *Appletons' Journal of Literature, Science and Art*, 7, no. 165 (May 25, 1872), 572–575. Thorpe discusses Clover's relations with the artists of the period and dubs the Parker and Clover shop the "First Art-centre in New York," apparently because of the lively traffic of artists, art patrons, and social personalities that took place there. Clover's son, Lewis P. Clover, Jr., won third prize in 1836, as an art student at the NAD, for "the best drawing from the 'Anatomical Figure'" (*Minutes* of the Council of the National Academy of Design, May 4, 1836).

86 Documented in Deák, *Picturing America*, entry 378.

87 Cited in Lois B. McCauley, *Maryland Historical Prints, 1752 to 1889* (Bal-

timore: Maryland Historical Society, 1975), p. 20. Bennett's aquatint is reproduced as fig. V26 on the same page. McCauley also reproduces a French aquatint (fig. V25, p. 19) which was evidently based on the Bennett view.

88 Several nineteenth-century views of the city from this vantage point were made, but none is as captivating as the Hill-Bennett aquatint. It is interesting to compare it with the steel engraving *New York, from Brooklyn Heights*, which appears in the *New-York Mirror* of April 19, 1834 (11, no. 42, opp. p. 329), designed by Thomas Kelah Wharton and engraved by A. W. Graham. While the engraving has its own appealing properties of topographical precision, clarity, and light, the design is basically conventional, and the whole effect is less buoyant than the Hill-Bennett rendering.

89 A view of the residence is shown in Deák, *Picturing America*, fig. 481.

90 A description of the portfolio with reproductions of the five views, based on a set of the aquatints owned by The New York Public Library, is contained in Deák, *Picturing America*, entries 468 through 472. Another, bound set is owned by The New-York Historical Society. Many of the watercolors executed by Harvey for his projected series are also owned by the Society, and are catalogued in Richard J. Koke, et al., *American Landscape and Genre Paintings in The New-York Historical Society* (Boston: G. K. Hall & Co., 1982), vol. 2, nos. 1142–1159. An article by Donald Shelley, "George Harvey and His Atmospheric Landscapes of North America," *The New-York Historical Society Quarterly*, 32 (April 1948), 104–113, was prepared at the time of the Society's exhibit of the Harvey watercolors in 1948.

91 *Harvey's Scenes of the Primitive Forest of America*, introduction.

92 Theodore E. Stebbins, Jr., *American Master Drawings and Watercolors* (New York: Harper and Row, 1976), p. 144. Stebbins reproduces in color one of Harvey's watercolor paintings of a Hudson River scene (fig. 113) entitled *Afternoon—Hastings Landing, Palisade Rocks in Shadow, New York*.

93 In the Council motion recording Bennett's dismissal, Frederick S. Agate was given the post of Keeper.

94 WJB's letters (the only extant documents in his hand) are dated January 13, and January 20, 1840. The handwriting is traditional nineteenth-century script, and the tone throughout is respectful. In the second letter, he asks for compensation in the amount of $600, but a statement from him, contained in the NAD Council meeting minutes of January 27, 1840, indicates his acceptance of the lesser amount.

95 The one exception to this is the documented opinion of Thomas S. Cummings, member of the NAD and its treasurer during the years of WJB's post as Keeper there. In his *Historic Annals of the National Academy of Design*, Cummings speaks of WJB as "an artist of considerable and varied ability," but unsuited as a Keeper because of his inability to control the students. "The removal of Mr. Bennett," he writes, "brought forth a display of his natural disposition—selfishness—which self-interest had caused for [a] time to be dormant." (p. 158). It is not known with which NAD officials WJB formed close ties. In the later of his two letters, the artist mentions John Ludlow Morton as "my friend and benefactor."

96 WJB's addresses are known only through exhibition records and New York City directories. As there are no private Bennett papers available to indicate the types of printmaking equipment he owned, it is informative to turn to Koke, "John Hill, Master of Aquatint," p. 74, to gain an idea of the kinds of tools and their cost in the possession of a busy aquatint artist. In this connection, Hill left substantial records.

97 A copy of the Tower volume is owned by The New York Public Library. The seven plates engraved by WJB are listed in Stokes, *Iconography*, vol. 3, pp. 875–876.

98 *The Diary of Philip Hone*, vol. 2, p. 624. The Croton Water Celebration, for which a special Ode was composed, is shown in a lithograph documented in Deák, *Picturing America*, entry 520.

99 The watercolor is documented in Deák, *Picturing America*, entry 526. It

is owned by The New York Public Library, which assigned the title to it in the absence of one by the artist.

100 The full title of the periodical was: *The New-York Mirror, and Ladies' Literary Gazette, Being a Repository of Miscellaneous Productions in Prose and Verse.* Its first number appeared on August 2, 1823. Frank Luther Mott gives a summary history of this influential American periodical in *A History of American Magazines, 1741–1850* (New York: D. Appleton and Company, 1930), vol. 1, pp. 320–330. The *Mirror* endured until 1857 during which time, Mott says (p. 330), it reflected "entertainingly and as truly as could be expected the life of New York and the nation."

101 *The New-York Mirror*, 17, no. 39 (March 21, 1840), 310.

102 A history of the American Art-Union and its practice of distributing prizes is contained in Mary Bartlett Cowdrey, *American Academy of Fine Arts and American Art-Union. Introduction, 1816–1852* (New York: The New-York Historical Society, 1953). A more recent account is given in Maybelle Mann, *The American Art-Union* (Otisville, N.Y.: ALM Associates, 1977). In reporting on the American Art-Union exhibit of 1844, Cowdrey writes that "the apparently favored artists, each of whom had five or more works purchased, were: S. B. Waugh, A. B. Durand, and W. J. Bennett" (p. 247). At this exhibit, ten bound sets of *Harvey's Scenes of the Primitive Forest of America*, with plates aquatinted by WJB, were also distributed as reported in Cowdrey, *American Academy of Fine Arts and American Art-Union. Exhibition Record, 1816–1852* (New York: The New-York Historical Society, 1953), p. 173.

103 *The New Mirror*, 1, no. 3 (April 22, 1843), 41. WJB had not shown work at the annual exhibitions of the NAD for three successive years: 1840, 1841, and 1842. In 1843 (his last NAD exhibit), he showed two Niagara Falls watercolors, but they did not represent new work.

104 WJB may be said to have set a change in motion when he became a charter member of the Associated Artists in Water-Colours and, later, a member of the Society of Painters in Water-Colours (the latter became the Royal Society of Painters in Water-Colours under the patronage of Queen Victoria). The two societies were undeniably successful in elevating the public response to watercolors to that of paintings of first rank, and in winning for them a solid place in popular affection.

William James Bennett: Chronology

1784

Born in England, birthplace probably London. The date is not secure but 1784 is the likely year (Bennett's death certificate in 1844 states he was sixty years old). No family records are extant.

1799

Registers as a student at the Royal Academy of Arts in London for a training period of probably seven years.

1800

During the decade of the 1800s, studies under Richard Westall (1765–1836), painter, Academician, book illustrator, and art instructor to the young Victoria before she ascended the throne. As one of the leading pioneers in watercolor painting, Westall guides Bennett's work in this direction.

1801

Exhibits his first painting, *View near Melrose*, at the Royal Academy. Address listed as 54, Upper Charlotte Street, at Mr. Westall.

1802

Exhibits two paintings, *Dover Castle—Evening* and *Rochester Castle—Morning* at the Royal Academy.

1803

Exhibits *West Cliff, Hastings* at the Royal Academy. Address listed as 15, Cleveland Street. Executes four aquatints after landscape sketches by John Carr, a prolific author of travel books.

1803–06

Serves with the British forces in the Mediterranean for about three or four years, interrupted by a brief sojourn in England. Returns from military service with a portfolio of drawings and watercolors of foreign places he visited.

1804

A painting of Bennett's sister Eliza by Richard Westall is exhibited at the Royal Academy.

1807

Exhibits *View of a Franciscan Convent* at the Royal Academy. Address listed as 7, Upper Titchfield Street. Becomes a charter member of the Associated Artists in Water-Colours.

1808

Executes three signed aquatints after designs by Mary Gartside, published in Gartside's elephant folio volume entitled *Ornamental Groups, Descriptive of Flowers, Birds, Shells, Fruit, Insects, &c.* (London, 1808).

1808–12

Exhibits for five years with the Associated Artists in Water-Colours on Bond Street. In 1811 and 1812 serves as treasurer with this group.

1810

Receives the first of many favorable reviews of his work. The initial critique, for a marine piece entitled *View of Stromboli* (near Sicily), is published in Ackermann's influential *Repository of Arts* in June 1810.

1812

Demise of the Associated Artists in Water-Colours, which Bennett helped to found. A watercolor, *Rochester Castle* (England), is favorably reviewed in the *Repository of Arts* for June 1812.

1814

Executes plates for William Combe's *A History of The University of Oxford*, published by Ackermann.

1816–23

Executes plates for W. H. Pyne's *The History of the Royal Residences of Windsor Castle*; William Combe's *The History of the Colleges of Winchester, Eton and Westminster*; James Ralfe's *The Naval Chronology of Great Britain*; Sir George Naylor's *The Coronation of His Most Sacred*

Majesty King George the Fourth; and the British Museum's catalogue of the collections held in its department of Greek and Roman antiquities. Among the artists linked to Bennett who worked on these projects are Richard Westall, William Westall (younger brother of Richard), John Hill, and Frederick Nash (Bennett's future brother-in-law).

1819

Exhibits with The Society of Painters in Oil and Water-Colours.

1820

Named an Associate of The Society of Painters in Water-Colours (which adopts its new name in this year: henceforth no more oils were to be shown in the annual exhibitions).

1821–25

Exhibits for five consecutive years with The Society of Painters in Water-Colours, presenting one watercolor each year.

1824

Eliza Bennett is married to Frederick Nash on April 17 in St. Pancras Church, London.

1826

Start of Bennett's American career. Presumed year in which he leaves England to reside permanently in the United States. Renews acquaintance with the English-born printmaker John Hill, who has also settled in America. Meets Henry J. Megarey, a bustling print entrepreneur in New York who commissions some work. Bennett paints, and executes in aquatint, his first topographic view of an American city, entitled *Broad Way from the Bowling Green*, as part of Megarey's projected New York street views. This series came to include only two other views: *South St. from Maiden Lane* and *Fulton St. & Market*.

1827

Elected to associate membership in the National Academy of De-sign (NAD), having satisfied the requirement of a year's residency in New York. Presents two landscapes at the NAD's annual exhibition. Lists his address as 105 Reed Street.

1828

Exhibits seven works at the annual exhibition of the NAD: four views of England, two of Italy, and one of New York. Continues work on *Megarey's Street Views in the City of New-York*. Changes address to 55 Orange Street.

1829

Travels to Niagara Falls to paint the first of a series of remarkable scenes of that cataract. Elected to full membership in the NAD. Exhibits four works there: two American views and two of Naples. Enters into collaboration with John Hill, who executes two Bennett views in aquatint for Henry Megarey. Agrees to undertake two watercolors of American scenery to be engraved on steel by Asher B. Durand.

1830

Appointed Keeper of the NAD with duties comparable to those laid down by the Royal Academy of Arts. An important component of his duties is the instruction of students. Takes up quarters in Clinton Hall, home of the Academy, located at the corner of Nassau and Beekman Streets in Manhattan. Participates in the annual exhibition with three English views, one of which was sold to Lewis P. Clover. Completes two watercolors, *Weehawken, from Turtle Grove* and *The Falls of the Sawkill*, which are engraved by Asher B. Durand and published in *The American Landscape* (1830).

1831

Executes in aquatint scenes of West Point and Baltimore, the earliest in the sequence of his celebrated folio views of American cities; publication of these nineteen views is undertaken chiefly by Lewis P. Clover and Henry J. Megarey. Exhibits seven works at the NAD: three foreign views, four American views. Draws praise from the *New-York Mirror* in a review of May 14 for his watercolor *Hay Sloops,*

Duane Slip. This is the first in a series of *Mirror* accolades that will be accorded to Bennett throughout his American career, primarily for his watercolors.

1832

Exhibits three American views and one of Naples at the NAD.

1833

Exhibits one nautical view at the NAD. The *New-York Mirror* publishes the Asher B. Durand steel engravings after Bennett's views of *Weehawken, from Turtle Grove* and *The Falls of the Sawkill*.

1834

Exhibits three American views at the NAD. Lists his studio address in the New York City directory as 9 Beekman Street; his home as 75 Thompson Street.

1835

Exhibits two American views at the NAD.

1836

Executes two aquatints after Nicolino Calyo's paintings of the great December 1835 fire in New York City. Undertakes an ambitious project, as aquatint master, with the Anglo-American artist George Harvey to execute a series of plates for *Harvey's Scenes of the Primitive Forest of America*. Only five aquatints are eventually realized for this series, published in 1841.

1837

Exhibits two American views at the NAD.

1838

Exhibits one English view at the Apollo Association in New York City.

1839

Exhibits one landscape (not otherwise identifiable) at the NAD and one English view at the Apollo Association.

1840

Dismissed as Keeper of the NAD early in January. Receives an engraved gold snuffbox as a farewell gift from his Academy students, reported in the *New-York Mirror* of March 21, 1840, which also lauds Bennett's work as a teacher. Moves his studio to 285 Broadway. Continues to attend NAD annual meetings through 1843.

1841

Exhibits one Hudson River view at the Apollo Association (later known as the American Art-Union).

1842

Prepares seven aquatints of New York State's Croton Aqueduct system based on F. B. Tower's drawings for Tower's *Illustrations of the Croton Aqueduct* (1843). Serves as a member of the Committee on Arrangements at the NAD.

1843–44

Commissioned by the *New Mirror* (formerly the *New-York Mirror*) to prepare and execute in aquatint ten drawings with American settings; they are published in issues of the *Mirror* dated 1843 and 1844. Presents two views of Niagara Falls at the NAD's 1843 annual exhibit.

1844

Exhibits six works at the American Art-Union (five American views, one Italian) which are later distributed as prizes. Lists his address as Nyack, New York.

Dies in New York City on May 13 and is buried in Greenwood Cemetery, Brooklyn. A resolution of mourning is adopted by the National Academy of Design in a special meeting convened on May 15.

Two of his American nautical scenes in aquatint are published posthumously in the *New Mirror*.

Checklist

1

Mary Gartside. *Ornamental Groups, Descriptive of Flowers, Birds, Shells, Fruit, Insects, &c. and Illustrative of a New Theory of Colouring from Designs and Paintings by M. Gartside.* London: William Miller, 1808. One volume in 4 numbers with aquatints after Mary Gartside including 3 aquatints by William James Bennett, 14 attributed to Bennett by Abbey. (Abbey, *Life in England*, 128) Arents Collections (figs. 3, 4)

Aquatint's ability to simulate the broad washes, delicate shading, and transparency of watercolor made it especially suited to illustrate watercolor drawing manuals, such as Mary Gartside's *Ornamental Groups*, which applied Sir Joshua Reynolds' rules for history painting to simplified and idealized still lifes.

Bennett's mastery of aquatint is evident in his beautiful, technically superb, signed floral and still-life arrangements for the Gartside book. The great collector and connoisseur J. R. Abbey was probably incorrect in attributing the unsigned plates to Bennett, since he preferred to work primarily in aquatint. The anonymous Gartside prints are poorly executed combinations of etching, soft ground, and roulette.

2

William Combe. *A History of The University of Oxford, Its Colleges, Halls, and Public Buildings.* London: Rudolph Ackermann, 1814. Two volumes with aquatints after various artists, including 2 aquatints by William James Bennett after William Westall. (Abbey, *Scenery of Great Britain and Ireland*, 280) Print Collection

William James Bennett was among the distinguished artists and skilled engravers who contributed to Rudolph Ackermann's superb illustrated plate books. Projects such as William Combe's *A History of The University of Oxford* reflect the period's enthusiasm for recording Great Britain's heritage and its architectural and natural wonders.

3

William Combe. *The History of the Colleges of Winchester, Eton, and Westminster; with the Charter-House, the Schools of St. Paul's, Merchant Taylors, Harrow, and Rugby, and the Free-School of Christ's Hospital.* London: Rudolph Ackermann, 1816. Book with aquatints after various artists, including 4 by William James Bennett. (Abbey, *Scenery of Great Britain and Ireland*, 440) Print Collection

For *The History of the Colleges*, Ackermann employed many of the same outstanding artists, engravers, and colorists who contributed to its earlier companion volumes, *A History of The University of Cambridge* and *A History of The University of Oxford*.

4

William H. Pyne. *The History of the Royal Residences of Windsor Castle, St. James's Palace, Carlton House, Kensington Palace, Hampton Court, Buckingham House, and Frogmore.* London: A. Dry, 1819. Three volumes with aquatints after various artists, including 23 aquatints by William James Bennett. (Abbey, *Scenery of Great Britain and Ireland*, 396) Print Collection (figs. 6, 7)

William H. Pyne (1769–1843), an etcher and painter as well as a writer, provided the text for a number of Ackermann publications. *The History of the Royal Residences* is Pyne's most extravagant literary effort, with one hundred aquatint views scattered throughout.

Reproductive engraving not only provided a living for many young artists, it also allowed them to perfect their printmaking technique. The even, fine grain and subtle tonal gradations of the aquatints for the Pyne publication show the extraordinary skill of these printmakers, among them Bennett.

In *The History of the Royal Residences*, the interior views were printed in sepia. The exterior views, including Bennett's *Frogmore*, were printed in two colors: brown for the foreground landscape and build-

ings, and blue for the sky. Printing in two colors provided a shortcut in laying down broad color areas, which could be finished off by the more laborious process of hand-coloring.

5

British Museum. Department of Greek and Roman Antiquities. *A Description of the Collection of Ancient Marbles in the British Museum.* London: W. Bulmer & Co., 1812–61. Eleven parts with engravings and aquatints after various artists, including 2 aquatints by William James Bennett after James Foster, Jr. Art and Architecture (fig. 5)

The English love for travel and for the ancient, foreign, and exotic spurred a revival of Classical studies in the nineteenth century, and encouraged publications on Greek topography and archeology. Along with numerous line engravings of antiquities in the British Museum, this book includes two Bennett aquatints, dated 1819, of the Temple of Apollo Epicurius, where many of the illustrated objects were found. The temple is set in an Arcadian landscape with a shady, grassy, foliaged foreground, and a brightly illuminated middle ground, which dissolve into a misty background. Bennett would apply this traditional English landscape painting formula derived from Claude Lorrain, and here interpreted by James Foster, Jr., with marvelous variation in his topographical views of America. This print is almost pure aquatint. Bennett added some accents of roulette work to the foliage and rocks in the foreground.

6

J. Ralfe. *The Naval Chronology of Great Britain; or an Historical Account of Naval and Maritime Events.* London: Whitmore and Fenn, 1820. Three volumes with aquatints after various artists, including one aquatint by William James Bennett after W. Waldegrave. (Abbey, *Life in England*, 342) Science and Technology Research Center

In this buoyant nautical view, Bennett captured the movement and drama of the sea with sweeping, painterly waves of aquatint. In both his English and his later American seascapes, Bennett faithfully followed well-established British artistic convention, which drew heavily upon Dutch seventeenth-century marine painting.

7

George Naylor. [*The Coronation of His Most Sacred Majesty King George the Fourth Solemnized in the Collegiate Church of Saint Peter Westminster upon the Nineteenth Day of July MDCCCXXI.* London: Henry George Bohn, 1839]. One volume with 45 colored aquatints after various artists, including 2 engraved by William Bond and William James Bennett, 2 engraved by William James Bennett. (Abbey, *Scenery of Great Britain and Ireland*, 260) Art and Architecture (fig. 31)

In the tradition of the grand festival book, Sir George Naylor's *Coronation of . . . King George the Fourth* is an extravagant, monumental production of elaborate hand-colored plates depicting the procession of members of the Royal Family and House of Lords. Only two of the intended five parts appeared before Naylor died in 1831. Henry G. Bohn acquired the plates and published them with Whittaker's plates of the *Ceremonial of the Coronation of George IV* in 1837 and 1839.

The plates combine aquatint, stipple, roulette work, and mezzotint. In *A Knight Grand Cross*, after Francis Philip Stephanoff (ca. 1788–1860), Bennett was responsible for the aquatint and roulette work in the costume; William Bond (active 1799–1833), the stipple portrait.

Bennett engraved two of the banquet scenes in the *Coronation*. In *The Ceremony of the Homage*, Augustus C. Pugin (1762–1832) provided the Gothic backdrop. Royal attendants were drawn by James Stephanoff (ca. 1788–1874). Bennett etched *The Royal Banquet* after a design by Charles Wild (1781–1835), an architectural painter and, like Pugin, a champion of the Gothic Revival.

8

Broad Way from the Bowling Green. ca. 1834. Aquatint. Proof before letters. Published by Henry I. [sic for J.] Megarey for *Megarey's Street Views in the City of New-York.* Image: 239 x 340 mm. (Stauffer 126, Deák 350) Eno Collection, Print Collection

Another impression. Aquatint, printed in pale green ink. Emmet Collection, Print Collection (fig. 8)

Broad Way from the Bowling Green, one of the first aquatints Bennett drew and etched in America, is part of a series of three views, including *South St. from Maiden Lane* and *Fulton St. & Market*, which he executed between

Fig. 31 *The Royal Banquet*. 1824. Colored aquatint, after Charles Wild.
From *Coronation of. . . King George the Fourth*. Art and Architecture
[checklist no. 7]

1826 and 1830. Published by Henry J. Megarey, this series is comparable in size and scale to Bennett's illustrations for the British Ackermann and Pyne volumes.

The Library has two impressions of this print. One is a proof printed before the letters were added. The other, with text, is printed in green ink. Since Bennett ordinarily used a delicate, rather gray ink for colored impressions, it is likely that neither was intended to be colored and sold.

9

South St. from Maiden Lane. ca. 1834. Aquatint. Published by Henry I. Megarey for *Megarey's Street Views in the City of New-York.* Image: 241 x 344 mm. (Stauffer 144, Deák 360) The Phelps Stokes Collection, Print Collection (fig. 10)

Without the customary addition of hand-coloring, it is possible to see readily how Bennett constructed most of this elaborate scene out of subtly differentiated areas of aquatint. He reserved etched line to define the figures, ships, and architecture, and for the intricate network of sails and rigging.

10

Fulton St. & Market. ca. 1834. Aquatint. Published by Henry I. Megarey for *Megarey's Street Views in the City of New-York.* Image: 237 x 341 mm. (Stauffer 137, Deák 362) Ford Collection, Print Collection

Another impression. Aquatint, printed in pale green ink. The Phelps Stokes Collection, Print Collection

Both of the Library's impressions of this print may be proofs. The gray-brown ink of the first is too dark for hand-coloring, and the green ink of the other would be a very atypical choice for Bennett's hand-colored impressions.

11

Weehawken. 1830. Engraving, by Asher B. Durand after William James Bennett. Published by Elam Bliss for *The American Landscape.* Printed by E. Wade. Image: 125 x 152 mm. (Grolier Club, D.232) Gift of John Durand, Print Collection

In 1830, Elam Bliss published *The American Landscape* with William Cullen Bryant, who wrote the text, and Asher B. Durand, who provided engravings after the paintings and sketches of prominent artists, including Bennett's *Weehawken* and *Falls of the Sawkill. Weehawken* looks across the bay at the Weehawken Bluffs from Turtle Grove. On the brow of the first bluff is the rock known as the Devil's Pulpit. Upriver are the Palisades.

12

Falls of the Sawkill. 1830. Engraving, by Asher B. Durand after William James Bennett. Published by Elam Bliss for *The American Landscape.* Printed by E. Wade. Image: 72 x 114 mm. (Grolier Club, D.233) Gift of John Durand, Print Collection

William Cullen Bryant celebrated the grandeur of the *Falls of the Sawkill* in *The American Landscape*: ". . . the dark precipices, the white stream pouring over them, the thick clouds of spray, and the forest in the back ground and on the sides, inclosing [sic] them as with a frame of verdure."

13

Niagara Falls./Part of the American Fall, from the foot of the Stair Case. 1829–30. Colored aquatint, by John Hill after William James Bennett. Published by Henry I. Megarey. Image: 518 x 427 mm. (Stauffer 1348, Deák 363) Lenox Collection, Print Collection (fig. 12)

Prints of Niagara Falls were purchased as keepsakes by tourists. In 1829–30, William James Bennett produced a series of four views of Niagara Falls for the publisher Henry J. Megarey. He etched two after his own compositions, and the other two, designed by Bennett, were engraved by John Hill.

In this scene with the Horseshoe Falls in the background, Hill combined etching with various textures of aquatint, and then roughened and burnished the plate to differentiate water, mist, rock, and sky. Hill's account books also record that he hand-colored the Bennett views of Niagara.

14

Niagara Falls./Part of the British Fall, taken from under the Table Rock. 1829–30. Colored aquatint, by John Hill after William James Bennett. Published by Henry I. Megarey. Image: 519 x 427 mm. (Stauf-

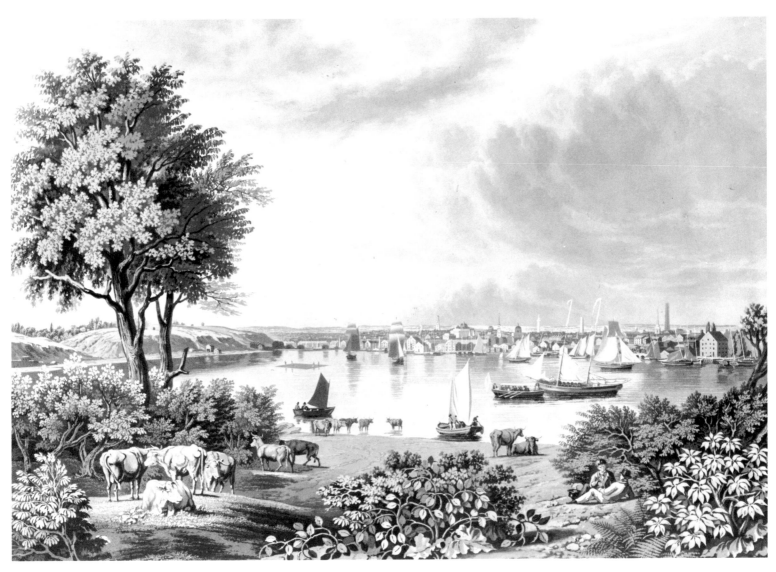

Fig. 32 *Baltimore. Taken near Whetstone Point.* 1831. Aquatint. The Phelps
Stokes Collection, Print Collection [checklist no. 18]

fer 1349, Deák 364) Lenox Collection, Print Collection (fig. 13)

In this view of the falls, nature is an all-powerful presence. Edmund Burke stated that from the Table Rock vantage point, "you feel more than any other, the height of the cataract and the weight of its waters." The overhang off Table Rock gives way to a sheer vertical cliff, and the rush of the water over Horseshoe Falls is so powerful that it creates thick clouds of dramatically highlighted spray.

15

Niagara Falls./To Thomas Dixon Esqr. this View of the American Fall, taken from Goat Island. . . . 1830. Colored aquatint. Second state. Published by Henry I. Megarey. Printed by John Neale at Illman & Pilbrows. Image: 405 x 532 mm. (Fielding 145, Deák 367) Print Collection (fig. 14)

Wild goats, the animals which once inhabited the island and gave the place its name, graze in the foreground of this idyllic scene. Bennett depicted the quick-moving rapids, the cascades of white water, the deep chasm below, which dissolves into spray, the landscape, and the sky, solely with various grains of aquatint. Only the goats were touched up with a flourish of roulette and a few etched lines.

Bennett's views of Niagara Falls were his largest prints to date, and unlike his English illustrations, these prints were issued singly, not as part of a magazine, book, or portfolio. The power and grandeur of the falls were well suited to the new, large format, which contrasts with the generally smaller-scale British travel prints, intended not for framing, but for the reader's pleasure in a bound volume.

16

Niagara Falls./To Thomas Dixon Esqr. this View of the British Fall, taken from Goat Island. . . . 1830. Aquatint. Published by Henry I. Megarey. Printed by J. Neale. Image: 408 x 518 mm. (Stauffer 142, Deák 368) Print Collection

Another impression. Colored aquatint. Print Collection (fig. 11)

Unlike John Hill, who combined aquatint with etching and burnishing to distinguish land, sky, and water, Bennett in the *View of the British Fall, taken from Goat Island* managed to capture the mist rising from the foam, the falls, and the flora and fauna, all in aquatint. Only in the figures did he add a touch of etching.

In this impression, the plate was obviously unevenly inked in the sky and background, and the impression could not have been intended for sale; an 1830 notation on the reverse of the sheet—which bears an early impression of *The Junction of the Sacandaga and Hudson Rivers* from *The Hudson River Portfolio*—indicates that this is a printer's proof. In the Library's second impression on view, the printer used a slightly lighter gray ink to accommodate the hand-coloring.

*17

Baltimore from Federal Hill. 1831. Colored aquatint. Second state. Published by Henry I. Megarey. Printed by J. & G. Neale at Illman and Pilbrows. Image: 422 x 615 mm. (Stauffer 123, Deák 378) The Phelps Stokes Collection, Print Collection (fig. 15)

Baltimore from Federal Hill is one of a series of views of American cities, some painted and engraved by Bennett, others engraved by Bennett after designs by other artists. Although Bennett does not seem to have conceived of these city views as a formal group of prints (nor were they published as such), in number and scale they are similar to such publishing enterprises as Joshua Shaw's *Picturesque Views of American Scenery* (1819–21) and William Guy Wall's *Hudson River Portfolio* (1821–25), both etched by John Hill. Hill's portfolios, issued with text, emphasized the picturesque qualities of the American landscape. Bennett, however, chose instead to record the young nation's growing urban centers in prints that were issued and sold individually for framing. His aquatints are a link between the city views in English travel books and the large-scale American city panoramas and bird's-eye views in demand during the second half of the nineteenth century.

*18

Baltimore. Taken near Whetstone Point. 1831. Aquatint. Proof before letters. Published by Henry I. Megarey. Printed by J. G. Neale. Image: 413 x 610 mm. (Fielding 124, Deák 379) The Phelps Stokes Collection, Print Collection (fig. 32)

After a visit to Baltimore in 1830, Bennett etched two views which focused on the city's vital harbor and active waterways. In this proof before the text was added, Bennett relied solely on tonal gradations and textural variations of aquatint to create dramatic lights and darks in the sky and to differentiate the foliage, grassy hill, the boat sails, and the watery reflections on the river. In a later proof, also before letters,

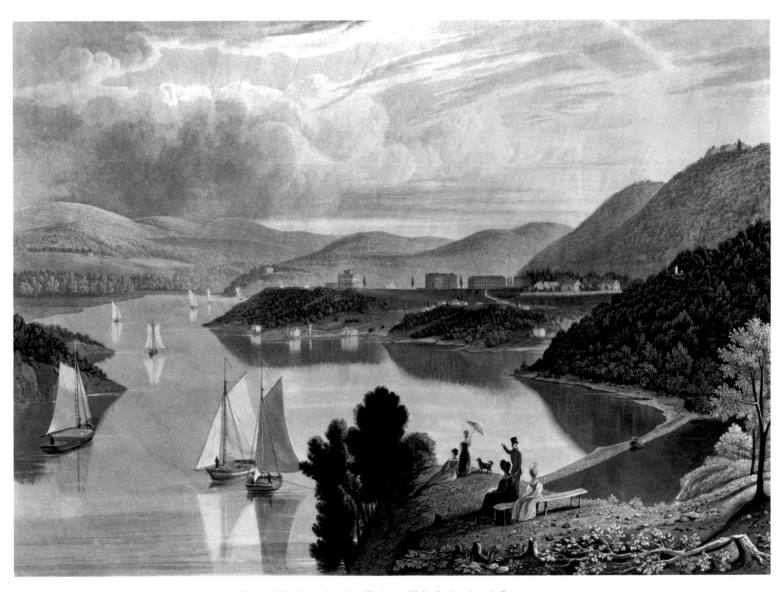

Fig. 33 *West Point, from above Washington Valley Looking down the River.* 1834.
Colored aquatint, after George Cooke. The Phelps Stokes Collection,
Print Collection [checklist no. 24]

at The Maryland Historical Society, Bennett added etched lines for the rigging on the boats and to accent the figures and animals.

*19

West Point, from Phillipstown./To Colonel S. Thayer Superintendent of the U.S. Military Academy, West Point. . . . 1831. Colored aquatint. First state. Published by Parker & Clover. Image: 402 x 568 mm. (Fielding 153, Deák 375) The Phelps Stokes Collection, Print Collection (fig. 16)

While Bennett was inspired by and a meticulous recorder of the world around him, like his fellow British and American view and marine painters, he worked within an established, conservative English tradition influenced by the French painter Claude Lorrain and by Dutch seventeenth-century seascapes. As in his view of West Point, this scheme—foreground foliage, often graced by an occasional spectator, a band of water, distant landscape, and an expanse of sky—appears in imaginative variations in all of Bennett's topographical compositions.

Lewis P. Clover, like Henry J. Megarey, published many Bennett prints. His looking glass and picture frame shop on Fulton Street was a haven for artists and writers in the city who would gather there to see American art exhibitions.

20

[*Boston,/From the Ship House, west end of the Navy Yard*]. Probably 1832. Watercolor. Sheet: 387 x 610 mm. (Deák 407) The Phelps Stokes Collection, Print Collection (fig. 17)

Bennett followed quite closely the composition and details of this watercolor in his aquatint.

*21

Boston,/From the Ship House, west end of the Navy Yard. 1833. Aquatint. Published by Henry I. Megarey. Modern impression, printed for the Club of Odd Volumes in 1901. Image: 543 x 692 mm. (Stauffer 125, Deák 407) S. P. Avery Collection, Print Collection

That aquatint can simulate the transparency of watercolor is evident even in this rather worn, twentieth-century impression of *Boston, From the Ship House.* Megarey would have paid an artist, such as John Hill, to hand-color his publications to duplicate even more closely the original watercolor.

*22

Boston,/From City Point near Sea Street. 1852–56. Aquatint. Second state. Published by John Levison. Image: 520 x 700 mm. (Fielding 125, Deák 408) Print Collection

Influenced either directly by Dutch seventeenth-century seascapes, or indirectly through conventional British marine paintings, Bennett carefully recorded the particularities of the harbor and receding city. Boston is framed by Bennett's favorite device, silhouettes of boats against a low horizon line. Architecture, ships, and sea are all unified by a luminous light.

Henry J. Megarey published the first edition of this print in 1833.

*23

View of New York Quarantine, Staten Island. 1833. Colored aquatint. Published by Parker and Clover. Image: 392 x 567 mm. (Stauffer 139) Eno Collection, Print Collection

Swift-moving sailboats take center stage in this aquatint delineating the coastal activities along the bay of New York. Bennett once again looked to English marine painting and seventeenth-century Dutch seascapes in his composition and attention to detail.

*24

West Point, from above Washington Valley/Looking down the River. 1834. Colored aquatint, after George Cooke. Third state. Published by Lewis P. Clover. Image: 400 x 576 mm. (Stauffer 151, Deák 412) The Phelps Stokes Collection, Print Collection (fig. 33)

Bennett etched four prints after paintings by George Cooke (1793–1849) in his series of views of American cities: this view of West Point, *Richmond, From the Hill above the Waterworks*, the *City of Washington From beyond the Navy Yard*, and the *City of Charleston S Carolina Looking across Cooper's River*. American-born George Cooke was a prolific painter of portraits, views, and historical subjects. He painted this scene of West Point in 1832 after he had left New York during a cholera epidemic for the safety of the Catskill Mountains.

*25

Richmond,/From the Hill above the Waterworks. 1834. Colored aquatint, after George Cooke. Copyrighted by George Cooke. Image: 453 x

Fig. 34 *View of the High Falls of Trenton, West Canada Creek, N.Y.* 1835.
Colored aquatint. The Phelps Stokes Collection, Print Collection
[checklist no. 27]

635 mm. (Stauffer 143, Deák 420) The Phelps Stokes Collection, Print Collection (frontispiece)

George Cooke poetically united nature with the distant city of Richmond. His topographical views reflect his sophisticated interpretation of the Claudian formula, which he had mastered while studying art in Florence and from copying Old Master paintings in Europe from 1826 to 1830.

*26

City of Washington/From beyond the Navy Yard. 1834. Colored aquatint, after George Cooke. First state. Published by Lewis P. Clover. Image: 455 x 628 mm. (Stauffer 149, Deák 422) The Phelps Stokes Collection, Print Collection (fig. 18)

The Potomac River provides visual and compositional continuity in this view of the nation's capital, painted by George Cooke when Washington was still a fledgling city. Bennett closely followed in his aquatint the harmonious composition and descriptive details of Cooke's painting, now in the White House (information on the location of the Cooke painting provided by Irving Atkins).

27

View of the High Falls of Trenton,/West Canada Creek, N.Y. 1835. Colored aquatint. Published by Lewis P. Clover. Image: 390 x 551 mm. (Deák 430) The Phelps Stokes Collection, Print Collection (fig. 34)

Bennett faithfully rendered the rugged purity of the landscape and the waterfall. In the nineteenth century, a growing interest in representing nature, fostered by the Romantic Movement, coincided with new discoveries in the natural sciences, particularly geology, meteorology, and botany.

28

View of the Natural Bridge, Virginia. ca. 1835. Colored aquatint, after Jacob C. Ward. Published by Lewis P. Clover. Image: 491 x 653 mm. (Fielding 139, Deák 441) The Phelps Stokes Collection, Print Collection (fig. 35)

In his *View of the Natural Bridge, Virginia,* Jacob C. Ward (1809–1891), a landscape and still-life painter, filled almost the entire sheet with the towering geological formation which dwarfs the diminutive tourists. The Natural Bridge was recorded in literature and art by countless awed visitors in the nineteenth century.

*29

New York./Taken from the Bay near Bedlows Island. 1836. Colored aquatint, after John Gadsby Chapman. First state. Published by Henry I. Megarey. Image: 413 x 627 mm. (Fielding 143, Deák 437) The Phelps Stokes Collection, Print Collection (fig. 36)

A prolific and versatile artist, John Gadsby Chapman (1808–1889) studied with George Cooke. In 1835 he painted this view of New York, where he worked from 1835 to 1848. In the aquatint version published by Henry J. Megarey in 1836, Bennett masterfully handled the choppy, glassy waves and the precisely delineated details of the ships and the distant city.

*30

Buffalo, from Lake Erie./To E. Johnson. H. Pratt. S. Wilkinson. B[.] Rathbun & A. Palmer Esqrs. and the Citizens of Buffalo: with Coll. Robt Steele of New York. 1836. Colored aquatint, after John William Hill. First state. Published by Henry I. Megarey. Image: 405 x 620 mm. (Stauffer 127, Deák 446) The Phelps Stokes Collection, Print Collection (fig. 19)

After serving an apprenticeship with his father, John Hill, John William Hill (1812–1879) was well versed in the compositional principles of the English topographical view, as in this aquatint of Buffalo, one of two prints by Bennett after the younger Hill's designs.

In the 1850s, Hill joined the Smith Brothers lithographic publishing firm and sketched the major cities of America. The aquatint's decline in America and on the Continent was inevitable, as publishers discovered that lithography could provide inexpensive, colorful images that satisfied the taste of the rising middle class for popular prints.

31

View of the Great Fire in New-York, Decr. 16th & 17th 1835 as seen from the top of the Bank of America. . . . 1836. Colored aquatint, after Nicolino V. Calyo. Published by Lewis P. Clover. Image: 415 x 607 mm. (Stauffer 140, Deák 438) Print Collection

Fig. 35 *View of the Natural Bridge, Virginia.* ca. 1835. Colored aquatint,
after Jacob C. Ward. The Phelps Stokes Collection, Print Collection
[checklist no. 28]

Nicolino Calyo (1799–1884), an Italian portraitist and miniature painter who settled in America in 1834, was an eyewitness to the Great Fire in New York of 1835. Throughout the night of December 16 and into the next day, he sketched the flames and the spreading devastation. From 1835 to 1840, Calyo painted a number of gouaches based on those drawings, including one of the burning Merchants' Exchange dated January 1836, the model for Bennett's aquatint.

32

View of the Ruins after the Great Fire in New-York, Decr. 16th & 17th 1835.... 1836. Colored aquatint, after Nicolino V. Calyo. Published by Lewis P. Clover. Image: 493 x 678 mm. (Stauffer 141, Deák 439) Print Collection

In this companion view to the night scene of the Great Fire, pandemonium has given way to quiet desolation. The smoldering ruins are seen in the early morning light. The facade of the South Reformed Dutch Church is still standing, but its interior has been destroyed. In the center background is the shell of the Merchants' Exchange, the focus of the previous view.

The publisher Lewis P. Clover quickly responded to the public interest in the Great Fire. His advertisement of 1836 states: "These beautiful ruins are fast disappearing, and in a few months no vestige of them will be left: in a few years, they will linger as a dream in the memory of the present generation, and the recollection of the most disastrous fire that ever befell this city will, like all earthly things, pass into oblivion."

*33

City of Detroit, Michigan. Taken from the Canada shore near the Ferry. 1837. Colored aquatint, after Frederick Grain. Published by Henry I. Megarey. Image: 394 x 624 mm. (Fielding 130, Deák 456) The Phelps Stokes Collection, Print Collection (fig. 20)

Bennett based an oil painting and later this aquatint on a sketch of Detroit by the landscape and panorama artist Frederick Grain (active 1833 to 1857). Bennett's oil painting is in the collection of the Detroit Institute of Art.

*34

New York,/from Brooklyn Heights. 1837. Colored aquatint, after John William Hill. Second state. Published by Lewis P. Clover. Image: 497 x 807 mm. (Deák 463) The Phelps Stokes Collection, Print Collection (cover)

New York, from Brooklyn Heights, after a work by John William Hill, is the largest and most ambitious print in Bennett's series of American city views. Hill's design broke with artistic conventions. He discarded the customary low vantage point, and seemingly climbed onto a Brooklyn Heights rooftop to record this panorama of Manhattan, a novel perspective that anticipated the bird's-eye views popular in the second half of the nineteenth century.

*35

City of Charleston S Carolina/Looking across Cooper's River. 1838. Aquatint, after George Cooke. Published by Lewis P. Clover. Twentieth-century impression. Image: 535 x 749 mm. (Fielding 128, Deák 458) The Phelps Stokes Collection, Print Collection (fig. 37)

Bennett was able to analyze and recreate in aquatint the subtleties of the paintings and watercolors he copied. He composed each print out of an intricate "jigsaw puzzle" of usually five or six different aquatint textures by progressively stopping-out areas with varnish and biting the plate with acid. Bennett's only adjustment to the aquatint surface of this view of Charleston was to highlight the sails in the center of the composition by burnishing that area of the plate before printing.

*36

Troy./Taken from the West bank of the Hudson, in front of the United States Arsenal. 1838. Colored aquatint. Published by Henry I. Megarey. Image: 400 x 644 mm. (Fielding 152, Deák 479) The Phelps Stokes Collection, Print Collection

While Bennett closely observed the world about him, his compositions reflect a careful selection, refinement, and rearrangement of man-made and natural elements. Above all, Bennett was a technical and artistic perfectionist who transformed everyday life into images tempered with grace and civility.

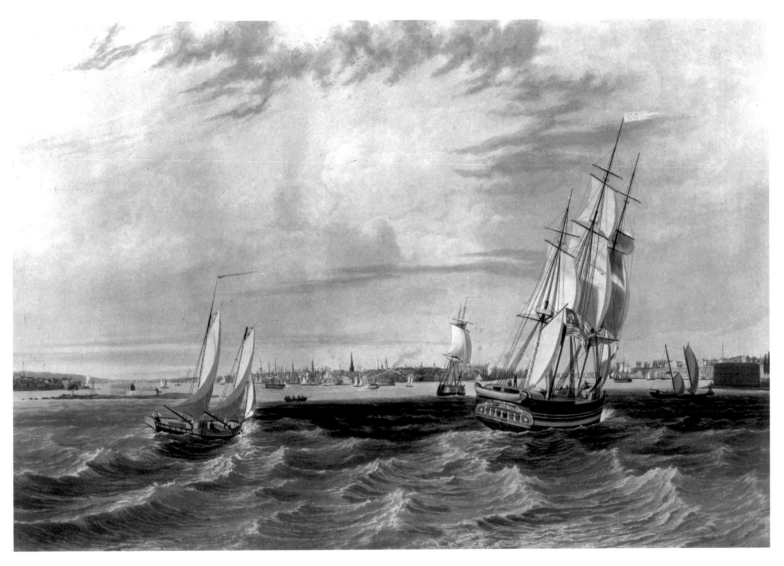

Fig. 36 *New York. Taken from the Bay near Bedlows Island.* 1836.
Colored aquatint, after John Gadsby Chapman. The Phelps Stokes
Collection, Print Collection [checklist no. 29]

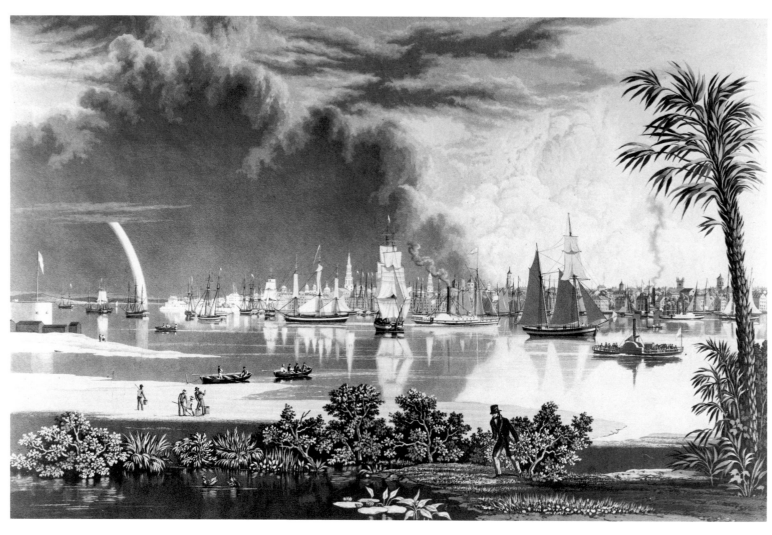

Fig. 37 *City of Charleston S Carolina.* 1838. Aquatint, after George Cooke.
The Phelps Stokes Collection, Print Collection [checklist no. 35]

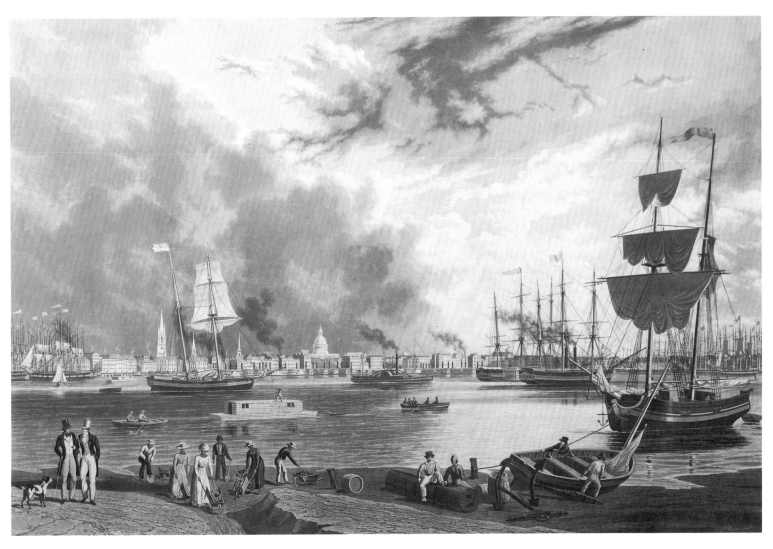

Fig. 38 *New Orleans, Taken from the opposite side a short distance above the middle of Picayune Ferry.* 1841. Colored aquatint, after Anthony Mondelli. The Phelps Stokes Collection, Print Collection [checklist no. 39]

***37**

A Brisk Gale, Bay of New York. 1839. Colored aquatint. First state. Copyrighted by William James Bennett. Image: 500 x 646 mm. (Fielding 141, Deák 491) The Phelps Stokes Collection, Print Collection (fig. 22)

Bennett chose this open-ended scheme of wind-tossed ships set against a distant city and stormy skies in several of his views of coastal cities.

38

No. 1 Harvey's/American Scenery,/representing different/Atmospheric/ Effects/at different times of/Day (title page).

Spring/No. 2/Burning Fallen Trees in a Girdled Clearing./Western Scene.

Summer/No. 3/A Road Accident, a glimpse thro' an opening of the Primitive Forest,/Thornville, Ohio.

Autumn/No. 4/Gigantic Sycamores. An Ox Team Crossing the Ford./Owl Creek, Ohio.

Winter/No. 5/Impeded Travellers in a Pine Forest./Upper Canada.

Colored aquatints, after George Harvey. From *Harvey's Scenes of the Primitive Forest of America*. New York: George Harvey, 1841. Image: 370 x 250 mm. (Abbey, *Travel in Aquatint*, 652, Deák 468–472) The Phelps Stokes Collection, Print Collection (figs. 23–27)

George Harvey (ca. 1800–1878) contemplated having a series of "Atmospheric Landscapes," his studies of various parts of the country at various seasons and times of day, etched and issued to subscribers in eight numbers. Only the first installment of four prints with title page was issued. Bennett expertly rendered the subtle tonal modulations using a particularly fine-grained aquatint, which, when combined with the delicately hued hand-coloring, creates a quiet, atmospheric mood in keeping with Harvey's intent.

***39**

New Orleans,/Taken from the opposite side a short distance above the middle of Picayune Ferry. 1841. Colored aquatint, after Anthony Mondelli. Published by Henry I. Megarey. Image: 425 x 637 mm. (Field-

ing 140, Deák 512) The Phelps Stokes Collection, Print Collection (fig. 38)

A scene and ornamental painter who worked in the theatre in New Orleans, Anthony Mondelli (active 1821 to 1856) sketched the view which provided Bennett with the design for his picturesque aquatint of the city.

40

[Mobile./Taken from the Marsh opposite the City near Pinto's residence]. Probably 1841. Watercolor, by William Todd. Sheet: 246 x 363 mm. (Deák 516) The Phelps Stokes Collection, Print Collection

***41**

[Mobile./Taken from the Marsh opposite the City near Pinto's residence]. 1842. Aquatint, after William Todd. Proof before letters. Published by Henry I. Megarey. Image: 367 x 635 mm. (Fielding 138, Deák 515) Emmet Collection, Print Collection (fig. 21)

Another impression. Aquatint, printed in green ink. Proof before letters. The Phelps Stokes Collection, Print Collection

Little is known about William Todd, whose delicate, subdued watercolor sketch of Mobile was the basis of Bennett's dramatic, compositionally tighter aquatint. Bennett skillfully manipulates the contrast between the dark-masted boat and white billowing clouds and the white-masted boat against brooding storm clouds.

The Library has two proof impressions of the view of Mobile. The first impression, in black ink, has been trimmed and lacks the upper section of the sky. Bennett used only pure, velvety aquatint in this early state, but in the second proof, a later state printed in green ink, he added etched and a few engraved lines to define the rigging and details on the sails, boats, and figures. The lighter-color ink has not recorded all the details of the clouds in the lower-left section of the sky. The New-York Historical Society owns a hand-colored, published version printed in a blue-gray ink.

42

F. B. Tower. *Illustrations of the Croton Aqueduct*. New York: Wiley and Putnam, 1843. Book with engravings and aquatints, including six aquatints by William James Bennett after F. B. Tower. (Stauffer 128–135) Science and Technology Research Center (fig. 28)

Fig. 39 [*View of High Bridge and the Harlem River*]. 1844. Watercolor.
The Phelps Stokes Collection, Print Collection [checklist no. 43]

View of the Jet at Harlem River. 1843. From *Illustrations of the Croton Aqueduct.* Image: 120 x 255 mm. (Stauffer 134) Print Collection

F. B. Tower worked for the Engineering Department in New York during the construction of the Croton Waterworks. This large masonry structure brought water from the Croton River along the Harlem River into New York. Tower published his account, *Illustrations of the Croton Aqueduct*, in 1843, following the official celebration in October 1842, when the water reached the city, coming via pipes across the Harlem River. Tower's essay was illustrated with etchings made after his sketches by William James Bennett, John Hill, and John William Hill.

43

[*View of High Bridge and the Harlem River*]. 1844. Watercolor. Sheet: 305 x 496 mm. (Deák 526) The Phelps Stokes Collection, Print Collection (fig. 39)

The view of the High Bridge is one of Bennett's last watercolors. He may have intended to issue an aquatint of this scene as a supplement to Tower's *Illustrations of the Croton Aqueduct*, which was published before the bridge over the Harlem River was completed. High Bridge, designed by John B. Jervis, chief engineer of the Croton Waterworks, was finished in 1848.

Bennett's inscription on the watercolor—"W. J. Bennett from Nature 1844"—suggests that he was recording nature directly. However, it is apparent that even in this composition he was unable to dispense entirely with the conventions of the English landscape tradition that had guided him so well throughout his career.

44

The Archipelago in a Levanter. 1843. Aquatint. Published by George P. Morris and Nathaniel P. Willis for *The New Mirror*. Image: 138 x 221 mm. (Stauffer 145) Print Collection (fig. 29)

45

Scene near Glenmary. 1843. Aquatint. From *The New Mirror*. Image: 123 x 198 mm. (Fielding 133) General Research Division

46

Catskill Mountains. 1843. Aquatint. From *The New Mirror*. Image: 125 x 196 mm. (Stauffer 135) Print Collection (fig. 30)

47

The Hay Sloops of the North River. 1843. Aquatint. From *The New Mirror*. Image: 130 x 194 mm. (Stauffer 147) Print Collection

48

The Equinoctial off Sandy Hook. 1843. Aquatint. From *The New Mirror*. Image: 122 x 185 mm. (Stauffer 136) Print Collection

49

View of the Bay of New York from the Battery. 1844. Aquatint. From *The New Mirror*. Image: 123 x 188 mm. (Stauffer 124) General Research Division

50

View of Weehawken Bluff from the Hudson. 1844. Aquatint. From *The New Mirror*. Image: 120 x 188 mm. (Stauffer 150) Print Collection

51

The U.S. Frigate Hudson Returning from a Cruise with a Fair Wind. 1844. Aquatint. From *The New Mirror*. Image: 127 x 200 mm. (Stauffer 146) General Research Division

52

The U.S. Brig Porpoise in a Squall. 1844. Aquatint. From *The New Mirror*. Image: 123 x 188 mm. (Stauffer 147) Print Collection

Bennett's last project was a series of ten aquatints (all but one are on view), based on his own designs, for *The New Mirror*, a literary and artistic magazine. They are smaller than his earlier, individually issued prints, but the technical quality of his printmaking remains high. By the 1840s, however, the fashion for aquatint was waning. Aquatint was being supplanted in the production of large-scale prints by the less expensive, less technically demanding medium of lithography, which along with wood engraving and steel engraving was also increasingly favored for book illustration.

Part of the series of folio views of American cities. All nineteen views from this series are represented in this exhibition, with the exception of Milwaukie Bound up Lake Erie passing the Light House at Buffalo. *The views are nos. 17, 18, 19, 21, 22, 23, 24, 25, 26, 29, 30, 33, 34, 35, 36, 37, 39, and 41 in this catalogue. For more information, see entry no. 17, Baltimore from Federal Hill.*

Selective Bibliography

Titles of books on exhibit in which the aquatints of William James Bennett appear are given in the Checklist, which begins on p. 70.

Abbey, John Roland. *Life in England in Aquatint and Lithography, 1770–1860. A Bibliographical Catalogue.* London: Curwen Press, 1953.

———. *Scenery of Great Britain and Ireland, 1770–1860. A Bibliographical Catalogue.* London: Curwen Press, 1952.

———. *Travel in Aquatint and Lithography, 1770–1860. A Bibliographical Catalogue.* 2 vols. London: Curwen Press, 1956–57.

Boston Museum of Fine Arts. *M. and M. Karolik Collection of American Paintings, 1815–1865.* Cambridge: Published for Museum of Fine Arts, Boston, by Harvard University Press, 1949.

———. *M. & M. Karolik Collection of American Water Colours & Drawings, 1800–1875.* 2 vols. Boston: Museum of Fine Arts, 1962.

Clark, Eliot C. *History of the National Academy of Design, 1825–1953.* New York: Columbia University Press, 1954.

Cowdrey, Mary Bartlett. *American Academy of Fine Arts and American Art-Union.* With a History of the American Academy by Theodore Sizer and a Foreword by James Thomas Flexner. Part 1: Introduction. Part 2: Exhibition Record. New York: The New-York Historical Society, 1953.

Cummings, Thomas S. *Historic Annals of the National Academy of Design.* Philadelphia: George W. Childs, 1865.

Deák, Gloria Gilda. *Picturing America, 1497–1899. Prints, Maps, and Drawings Bearing on the New World Discoveries and on the Development of the Territory That Is Now the United States.* 2 vols. Princeton: Princeton University Press, 1988.

De Silva, Ronald Anthony. "William James Bennett: Painter and Engraver." Unpublished Master's thesis written for the University of Delaware, 1970. Photocopy held in the Print Room of The New York Public Library.

Dunlap, William. *A History of the Rise and Progress of the Arts of Design in the United States.* New ed. Illustrated, edited with additions by Frank W. Bayley and Charles E. Goodspeed. 3 vols. Boston: C. E. Goodspeed and Co., 1918.

Fielding, Mantle. *American Engravers upon Copper and Steel . . ., A Supplement to David M. Stauffer's "American Engravers."* Philadelphia, 1917.

Graves, Algernon. *Dictionary of Artists Who Have Exhibited Works in the Principal London Exhibitions of Oil Paintings from 1760 to 1893.* New York: Burt Franklin, 1970.

———. *The Royal Academy of Arts: A Complete Dictionary of Contributors and Their Work from Its Foundation in 1769 to 1904.* 8 vols. New York: Burt Franklin, 1972.

Grolier Club of the City of New York. *Catalogue of the Engraved Works of Asher B. Durand.* New York: Grolier Club, 1895.

Holme, Charles, ed. *The "Old" Water-Colour Society, 1804–1904.* London: The Studio, 1905.

Koke, Richard J. *A Checklist of the American Engravings of John Hill (1770–1850), Master of Aquatint.* New York: The New-York Historical Society, 1961.

———. "John Hill, Master of Aquatint, 1770–1850." *The New-York Historical Society Quarterly*, 43 (January 1959), 51–118.

———, et al. *American Landscape and Genre Paintings in The New-York Historical Society*. 3 vols. Boston: G. K. Hall & Co., 1982.

Lane, James W. "New Exhibitions of the Week." *The Art News*, XXXVIII (January 27, 1940), p. 38.

McCauley, Lois B. *Maryland Historical Prints, 1752 to 1889: A Selection from the Robert G. Merrick Collection, Maryland Historical Society, and Other Maryland Collections*. Baltimore: Maryland Historical Society, 1975.

McKinsey, Elizabeth. *Niagara Falls: Icon of the American Sublime*. Cambridge: Cambridge University Press, 1985.

Mann, Maybelle. *The American Art-Union*. Otisville, N.Y.: ALM Associates, 1977.

National Academy of Design. *Constitution and By-Laws of the National Academy of Design*. New York: Printed for the National Academy of Design, 1826.

———. *National Academy of Design Exhibition Record, 1826–1860*. 2 vols. New York: Printed for The New-York Historical Society, 1943.

The New-York Mirror, and Ladies' Literary Gazette. 1823–31. In 1831 the title was changed to *The New-York Mirror. A Weekly Journal Devoted to Literature and the Fine Arts*; this title was retained, with slight variations, through 1842. In 1843–44 the publication was known as *The New Mirror of Literature, Amusement and Instruction*.

Prideaux, S. T. *Aquatint Engraving*. London: Duckworth & Co., 1909.

The Repository of Arts, Literature, Commerce, Manufactures, Fashions and Politics. 40 vols. London: R. Ackermann, 1809–28.

Roget, John Lewis. *A History of the "Old Water-Colour" Society, Now the Royal Society of Painters in Water Colours, With biographical notices of its older and of all deceased members and associates. . . .* 2 vols. London: Longmans, Green & Co., 1891. Reprint. Woodbridge, Suffolk: Antique Collectors' Club, 1972.

Sandby, William. *The History of the Royal Academy of Arts from Its Foundation in 1768 to the Present Time. With Biographical Notices of All the Members*. 2 vols. London: Longman, Green, Longman, Roberts, & Green, 1862. Reprint. London: Cornmarket Press, 1970.

Shelley, Donald A. "George Harvey and His Atmospheric Landscapes of North America." *The New-York Historical Society Quarterly*, 32 (April 1948), 104–113.

Stauffer, David McNeely. *American Engravers upon Copper and Steel*. 2 vols. New York: Grolier Club, 1907.

Stebbins, Theodore E., Jr. *American Master Drawings and Watercolors: A History of Works on Paper from Colonial Times to the Present*. New York: Harper and Row, 1976.

Stokes, I. N. Phelps. *The Iconography of Manhattan Island, 1498–1909*. 6 vols. New York: Robert H. Dodd, 1915–28.

Weitenkampf, Frank. *American Graphic Art*. New York: Henry Holt and Co., 1912.

◆ ◆ ◆

This book was designed by Donna Moll
and set in Fournier type at The Meriden-Stinehour Press, Lunenburg, Vermont.
Three thousand copies were printed by offset lithography
on Mohawk Superfine at The Meriden-Stinehour Press,
Meriden, Connecticut.